squash

50 TRIED & TRUE RECIPES

Julia Rutland

Adventure Publications
Cambridge, Minnesota

Cover and book design by Lora Westberg
Edited by Emily Beaumont

Cover images: All images by Julia Rutland unless otherwise noted.
AlexeiLogvinovich/shutterstock.com: Cool Whip (used for
pumpkin pie—left, bottom photo); AnastasiaKopa/shutterstock.
com: bowl (used for squash chowder—right, middle photo); Pro-
lightstudio/shutterstock.com: background; Rimma Bondarenko/
shutterstock.com: bowl (used for ice cream—top, middle photo)

All images by Julia Rutland unless otherwise noted.
Used under license from shutterstock.com:
Chris Brignell: 1e; chiyacat: 12d; BW Folsom: 12c; George3973:
14a; Brent Hofacker: 11b; JIANG HONGYAN: 13f; JeniFoto: 13c;
Nikolay Kurzenko: 13b; Lotus Images: 12f; Sarah Marchant: 14b;
matkub2499: 12b; V J Matthew: 2-3; miwa-in-oz: 12a; Smil-
eus: 13e; akepong srichaichana: 11a; Krailurk Warasup: 13d;
whitemaple: 13a

10 9 8 7 6 5 4 3 2 1

Squash: 50 Tried & True Recipes
Copyright © 2019 by Julia Rutland
Published by Adventure Publications
An imprint of AdventureKEEN
330 Garfield Street South
Cambridge, Minnesota 55008
(800) 678-7006
www.adventurepublications.net
All rights reserved
Printed in China
ISBN 978-1-59193-909-2 (pbk.); ISBN 978-1-59193-910-8 (ebook)

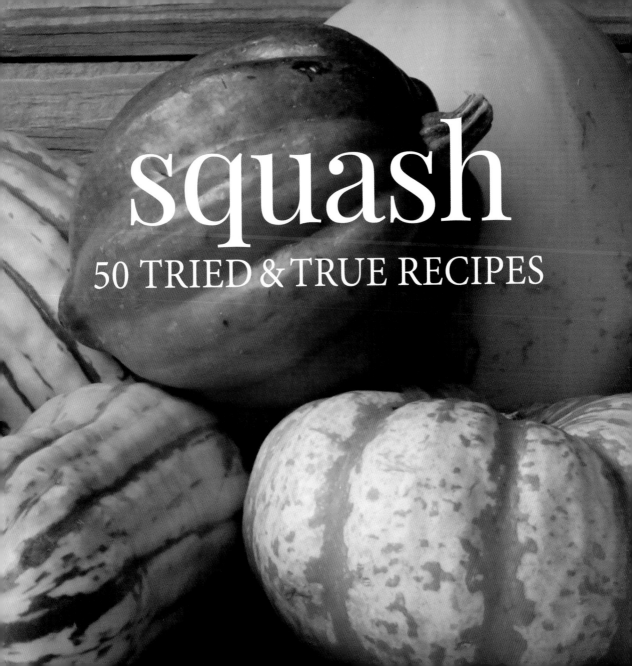

squash

50 TRIED & TRUE RECIPES

Acknowledgments

Much love to my family for eagerly (or at least willingly) tasting all my creations. Thank you to my daughter Emily, who only likes winter squashes, and my daughter, Corinne, who prefers only summer, as well as my husband, Dit, who eats and likes just about anything I serve.

Thanks to, dear friends Susan Dosier and Jackie Mills for your recipes, ideas, support, and love. Thank you to Robert Schueller at Melissa's Produce for helping me find the off-season goodies. Thank you to the Ashby Farm Circle Book Club and Loudoun County Master Gardeners for being good sports and tasting any recipes I wrapped up and brought to gatherings. Thank you to Brett Ortler and Emily Beaumont at AdventureKEEN for guiding me through this book and others. I appreciate and love you all!

squash

50 TRIED & TRUE RECIPES

Table of Contents

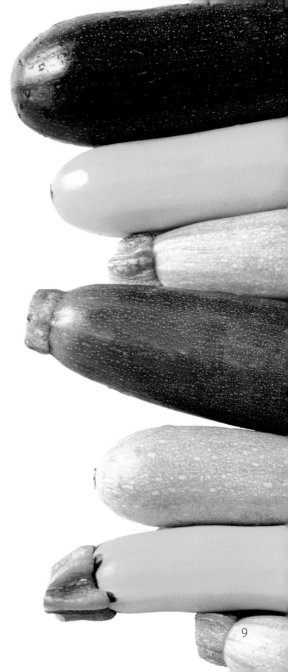

About Squash: Summer and Winter

From acorn to zucchini, squashes are delicious, and they are readily available at grocery stores, farmers markets, and in gardens.

Squash, members of the gourd family, are native to the Americas and have been an important food source for millennia. Originally, they were likely hollowed out to be used as cups, bottles, or floats for fishing nets. Eventually, squashes were cultivated to be a tasty and nutritious food source. Various Native American groups included squash in companion plantings with maize (corn) and beans. Known as "the three sisters," these three crops were planted close together in flat-topped mounds to benefit each other. The tall maize plants would give beans a structure they could climb. Beans would fix nitrogen in the soil, providing a natural fertilizer; some groups also added fish carcasses to further enrich the soil. Large squash leaves would spread along the ground, blocking the sun to inhibit weeds, while maintaining moisture in the soil.

Squash are herbaceous vining plants in the gourd family, Cucurbitaceae. While consumers consider squash a vegetable, botanists know squash are really a fruit. Yes, really—just like tomatoes, bell peppers, peas, okra, olives, corn, and beans. A fruit is the fleshy product of a plant that contains seeds. The word vegetable refers to other edible plant parts, such as leaves, stems, roots, and flowers.

While there are hundreds of species, consumers divide them into two broad categories: summer and winter. This designation is not based on growing season but on harvest time and shelf life. Summer squash is picked somewhat immature—with tender, edible skin—and eaten soon after. For winter squash, the term "winter" doesn't mean that it was grown then but that it was harvested later and can often be stored through much of the winter season.

Summer Squash Characteristics
- harvested from early summer when the fruit is tender and small, compared to its potential mature size (Anyone who has grown zucchini and let one achieve bowling-pin size or larger will understand.)

- soft and edible seeds and skin

- high water content

- can be consumed immediately after picking

- quickly perishable and should be stored in the refrigerator

- can be eaten raw

- cooks quickly

Winter Squash Characteristics
- harvested when mature, at the end of summer or in fall

- thick, hard, inedible skin (Some skin on winter squash is soft enough to eat.)

- firmer and drier flesh

- should be cured to further harden skin

- can be stored for months

- takes longer to cook than many other fruits and vegetables

TYPES OF SQUASH
SUMMER

Zucchini: These are probably the most well-known of the summer squashes. Naturally found in shades of green, these cylindrically shaped fruits have been bred in colors from a very dark green to bright yellow. The interior is a pale white or cream color. Their flavor is best when small; likewise, the texture is best when seeds are small.

Yellow Straightneck and Crookneck: These common varieties of yellow squash both have thin, glossy skin in a pale-canary yellow with a pale-yellow interior. Both have a tapering, cylindrical shape, but the stem end of crookneck hooks into a curve.

Pattypan: These adorable summer squash have scalloped edges and a flattened, disc-shape body. They are grown in many colors: pale green, dark green, white, yellow, and orange. They are small and generally grown to no more than 2–3 inches in diameter.

Chayote: Also called Mexican pear squash or mirliton in the Louisiana area, chayote look like pale green avocados or large pears. The skin is tough and often peeled after cooking. The large center seed, again like an avocado, is often removed, although it is edible. They are not necessarily a "summer squash" but a cousin in the gourd family. They are usually considered summer squash because of their perishability and how they are eaten.

WINTER

Acorn: Oval shape, similar to an acorn, with deep grooves running from stem to blossom end, acorn squash are available year-round in markets. They are commonly dark green, with an orange blaze along the side. New varieties have bright gold or white exteriors. The flesh is yellow to pale orange. Acorn squash are very commonly halved and stuffed. Peeling is difficult but not critical because the skin is edible.

Buttercup: These squashes have a roundish shape with a flattened top. They are often found with a dark green exterior, but some varieties are bright orange or light green with mottled markings. The thick flesh is dense and orange.

Butternut: Shaped like a chubby bowling pin, butternut are available year-round. The skin is tan with a vibrant orange interior. The interior is dense, especially in the neck, which is solid and contains no seeds. Butternut yields a lot of edible flesh.

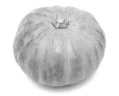

Calabaza: This squatty, pumpkin-shaped squash with mottled skin comes in shades of green, orange, amber, and cream and is speckled or striped. The skin is very tough and somewhat challenging to peel. These are sometimes sold in chunks in markets and are popular in Latin American cuisine. Calabaza has a flavor similar to butternut.

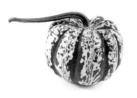

Carnival: This squash has a similar shape as acorn, but it has a pale creamy color base with orange and green stripes along the grooves. It is often used as decoration, but its flavor is sweet and nutty like acorn or butternut.

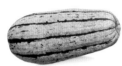

Delicata: This squash has a long, cylindrical shape with grooved skin. Delicata is available from fall until early winter. Delicata is primarily yellow inside and out but may also have shades of orange and green on the edible skin. It is often sliced lengthwise, seeded, and then cut into semicircles before being roasted or stuffed and baked. It is similar in flavor to butternut squash or a sweet potato.

Hubbard: Hubbard squash are some of the largest kinds of squash, as they can grow up to 50 pounds (but you'll usually see them at no more than 20 pounds in stores). They come in a variety of colors, from bluish green to orange. The shell is extremely hard, so many are sold in precut portions. The skin is difficult to peel when raw, so it is usually cooked with the skin on.

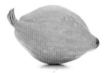

Kabocha: This medium-size squash looks like a squatty pumpkin with a flattened top. The exterior is often dark green with pale green mottling, and the fine-grained interior is bright yellow. The texture is firm, and the flavor is reminiscent of a sweet potato. It can be difficult to peel; cook with the skin on and remove it later.

Pumpkin: There are many types of edible pumpkins, but consumers need to be aware that the basketball-size and larger pumpkins in large bins outside the market are grown as ornamentals. They are bred for their eye-catching size or for thin shells that make for easier carving. They are edible, but their flavor is often bland. Baking pumpkins are small, orange globes with sweet, smooth flesh.

Spaghetti: This squash is well-known for its stringy flesh that, when cooked, separates into filaments akin to spaghetti. It is oval shaped with a pale- to canary-yellow exterior and interior.

Sweet Dumpling: This cream-and-white-striped squash is small, about the size of a large apple; each one is a single serving. Its flavor is sweet. There's no need to peel them because the tender skin can be eaten.

Turban: This large squash often weighs about 5 pounds and has a lopsided, irregular shape that could possibly resemble a turban, depending on growth. It's found in a range of colors, from mottled green and orange, to red and yellow, often with stripes of these colors. The skin is difficult to remove, so it is often cooked first and peeled after.

Planting and Growing Squash

Squashes, like most other garden produce, grow well with full sun in moist, well-drained soil that's been amended with compost.

You can start seeds indoors about 2–4 weeks before the last spring frost. Squash seedlings are sensitive, so use peat pots or some other plantable containers to avoid breaking the roots. Harden the plants before transplanting by placing them outside in a sheltered location for a few hours each day.

For best results, directly sow seeds outdoors when the soil temperature stays warm, at least 60° but ideally 70° (about 2 weeks after the last frost date). Plant 2–3 seeds per hole, about 1 inch deep. Or plant 4–5 seeds together in a mound about 6–10 inches high and 1 foot across. When seedlings are about 3 inches tall and two sets of "true" leaves appear (after the first two rudimentary ones), snip with scissors to the strongest two seedlings.

Space seeds and/or bushy summer squash plants about 3 feet apart in all directions. Winter squashes grow as a vine. Try planting them where they can sprawl without blocking paths. Rows should be 3–5 feet apart and hills 5–8 feet apart.

Summer squash can be caged or trained on a trellis; the increased air circulation will benefit the plant. Winter squash can be trellised, but supports will be needed to hold the heavy fruit.

The first flowers on a squash plant are male, so don't expect anything to grow from them. Soon, both male and female flowers appear; with proper pollination, small squash appear from the female flowers. If you like to save seeds and discover that next year's harvest doesn't look like

the squash from which you saved the seed, here's why: Squash may cross-pollinate if two within the same species are grown close together. For example, zucchini and straightneck squash or even acorn might produce a hybrid, but you won't accidentally cross a zucchini with a butternut because they are not as closely related. Farmers typically breed a hybrid to create better taste or disease resistance. But sometimes it's for aesthetics—those warty, multi-colored, and strangely shaped pumpkins and gourds seen around Halloween are bred for decor.

Summer squash develops quickly. Because winter squashes stay on the vine for a while, consider placing a wood plank under the fruit to reduce insect damage or the chance of them rotting on damp ground.

Container Gardening

If you don't have a dedicated garden space, consider container gardening. Summer squashes are often bushy varieties, which take up less space and are easier to manage in a container than vining types. Sow about three seeds in the center of a 10-inch or larger container, thinning out the weakest seedlings.

Place two or more plants close together for adequate pollination. Container gardens tend to need more frequent watering.

Harvest: Summer

Most summer squash plants take about 50–60 days to mature. Check plants every day, as they grow quickly and new ones show up very frequently.

Harvest summer squash when small and tender. And I can't say this enough—check every day or you may end up with zucchinis that resemble a kindergartner's Wiffle Ball bat.

Zucchini and yellow squash are best when about 6 inches long. Large squash are tough, full of large seeds, with little flavor. And leaving mature squash on the vine saps energy that the plant could be using to produce new squash. If you do end up with large squash, hollow out and remove the seeds. Large ones won't be very flavorful, but you can cube them to use in highly seasoned soups and stews. If they grow so large to be pithy in the center, give them to the birds or compost.

Cut squash off the vine with a 1-inch stem using sterilized pruning shears or a knife. Breaking or twisting them off could tear stems, inviting pests and disease to enter. And remember, the more you harvest, the more the plant will produce.

Tender summer squash are best eaten immediately after picking or can be stored, unwashed, in a plastic bag in the refrigerator for about 2–5 days.

Harvest: Winter

Winter squash plants are mature when the fruit has a deep color and a hard rind, about 70 to 120 days after germination. Winter squashes should mature on the vine or they may taste bland and watery. You can tell when a winter squash is ready to harvest if the rind is not easily dented with a thumbnail. Leave 2–3 inches of stem on the fruit.

Winter squash need to be cured before storing to reduce excess water in the fruits. Curing concentrates the natural sugars, lengthens storage time, and reduces the chance of rot. (Note that acorn squashes do not benefit from curing.) To cure, place in a warm location with good air circulation for 10–14 days until the stems turn gray and shrivel. After curing, winter squash will easily keep for weeks to months. Store acorn squash up to a month, spaghetti for 4–5 weeks, buttercup about 3 months, butternut up to 6 months, and blue Hubbard up to 6 or 7 months.

Have Extras?

With the proper conditions, summer squash can be ferocious growers, resulting in more than you can eat. In general, canning isn't advised because summer squash will turn mushy during processing. However, you may process yellow squash or zucchini into pickles. (Cucumbers are in the same family as squash and basically own the word "pickle.")

Freezing is a great option for an overabundant harvest. Slice, chop, cube, or grate summer squash and blanch first to deactivate enzymes that would cause them to become discolored or mushy in the freezer. To blanch, drop cut pieces into boiling water about 30 seconds to 3 minutes, depending on size, or just until slightly tender. Then cool immediately in ice water to stop the cooking process. Drain well, ideally blotting with a towel to remove excess water. For easy use, freeze zucchini pieces in a single layer on a sheet pan until frozen, then transfer to a freezer bag, pushing out as much excess air as possible. Freeze 6 months to a year.

Buying

Select small summer squash for the best flavor. Their skins are tender; purchase squash with smooth, blemish-free skin and avoid bruising it in the shopping cart and bags.

Select winter squash that feels heavy for its size. The skin should be hard and without dents or soft spots.

The Basics: Cooking

Summer

Summer squash is easily enjoyed raw or lightly cooked. Cooking summer squash is simple and fast, but obviously thicker pieces take longer to cook. Because of their high water content, squash can sometimes "water out" in recipes, especially in casseroles. To help prevent this, squash can be sliced and lightly salted. Let it stand about 15–30 minutes to allow water to exude, and then pat dry with a paper towel. You can also microwave slices for a minute or two and let drain on paper towels. Some recipes include dried breadcrumbs with the squash to absorb excess liquid.

Sauté or Stir-Fry: Heat about 1 teaspoon oil for each cup of chopped, sliced, or julienned squash. Cook, stirring frequently, 4–5 minutes.

Roast/Bake: Cut into slices and brush with oil. Bake at 350° to 450° for 5–10 minutes.

Grill: Cut ends from squash and split in half lengthwise, or cut it into thick slices. Brush with oil and grill over medium-high heat 3 minutes on each side or until tender.

Fry: Zucchini is perfect for a fried snack (yellow less so because the seeds can be larger). Cut into slices or long strips, zucchinis are great when battered and deep-fried for 2–3 minutes.

Boil: Place sliced or chopped squash in boiling salted water to cover; cook 1–3 minutes or until tender.

Microwave: Cut ends from squash and cut into ¼-inch-thick slices. Place in a shallow bowl and sprinkle with water. Cook 4–5 minutes or until tender.

Summer Squash Equivalents:

1 pound fresh = 3 medium (about 5–6 ounces each)

1 pound fresh = 3 cups raw slices

1 pound fresh = 2½ cups cubed

1 pound fresh = 2 cups grated and packed

Winter

Cutting winter squashes can be tricky to downright dangerous. Their hard texture requires a stabilized cutting board (put a damp paper towel underneath to prevent slipping) and a large, sharp knife. An 8-inch chef's knife is the kitchen workhorse, but if you have large squashes and a 10-inch blade, that will work even better. A 6-inch chef's knife is appropriate for smaller squash. If you find yourself putting a lot of pressure on a squash, use a larger knife. One trick to getting through a hard squash is to prick it a few times with a fork and microwave it on high for about 2 minutes. That will soften the rind up enough to cut through without cooking the entire thing.

Winter squashes have a dense, rich texture that is ideal for purees. Once cooked, remove seeds and skins, if necessary. Mash with a potato masher; run through a food mill; or puree with an immersion blender, blender, or food processor. Some types, especially pumpkins, may have a watery texture. Strain through a colander lined with a layer of cheesecloth or coffee filters. Or spoon into a jelly bag and let stand to separate puree from liquid.

Roast/Bake halves for purees and soups: Cut squash in half. Scoop out seeds and discard. Place, cut side down, in a 13x9-inch baking pan or rimmed baking sheet. Pour in ¼- to ½-inch water. Bake at 350° for 40–50 minutes or until tender when tested with the tip of a knife. The water keeps the squash moist and will release easily from the skin but is optional. This technique is ideal for large squash like butternut, Hubbard, kabocha, spaghetti, or pumpkin.

Roast/Bake halves: Cut squash in half. Scoop out seeds and discard. If desired, brush with melted butter or oil and sprinkle with salt and pepper and/or brown sugar and cinnamon. Bake at 350° for 30–50 minutes or until tender when tested with the tip of a knife. This technique is ideal for acorn and carnival, delicata, and other small squash with edible skin or fluted sides.

Roast/Bake cubes and slices: Cut squash in half. Remove seeds; discard. Peel and cut into ½- to 1-inch cubes. Place in a single layer on a sheet pan and drizzle with olive oil, salt, and pepper. Bake at 350° to 400° for 25–30 minutes, turning occasionally, until tender.

Grill: Preheat grill to medium heat. Cut in half; discard seeds. Peel squash, if desired. Cut squash into ½-inch-thick slices. Brush with olive oil and sprinkle with salt and pepper. Grill about 7–10 minutes on each side.

Boil/Steam: Cut peeled and seeded squash into 1-inch cubes. Boil 10–15 minutes or until tender but still firm.

Microwave: Pierce whole squash all over with a fork or the tip of a sharp knife. Microwave at high for 5–10 minutes or until tender throughout. Let stand until cool enough to handle. Cut in half and remove seeds. Scoop flesh out of peel.

Instant Pot: Cut squash in half, peel, and remove seeds. Place halves on a short steaming rack and pour in 1 cup of water. Cook on high pressure for 7 minutes for acorn and spaghetti, 12 minutes for butternut and pumpkin. Allow a natural pressure release for about 5 minutes. If using cubes, cook about 6 minutes and use a quick release. You can also cook a squash whole, but timing is trickier and doesn't save that much time, or effort. Estimate about 25 minutes at high pressure for butternut, with a natural release for 10 minutes. Let it cool enough to handle; then slice in half, peel, and cut as desired.

Winter Squash Equivalents:

1 pound uncooked = 1 cup cooked and mashed

1 pound uncooked = 3 cups cubed

12 ounces frozen and thawed puree = about 1 cup

2½ pounds whole butternut = 3 cups pureed

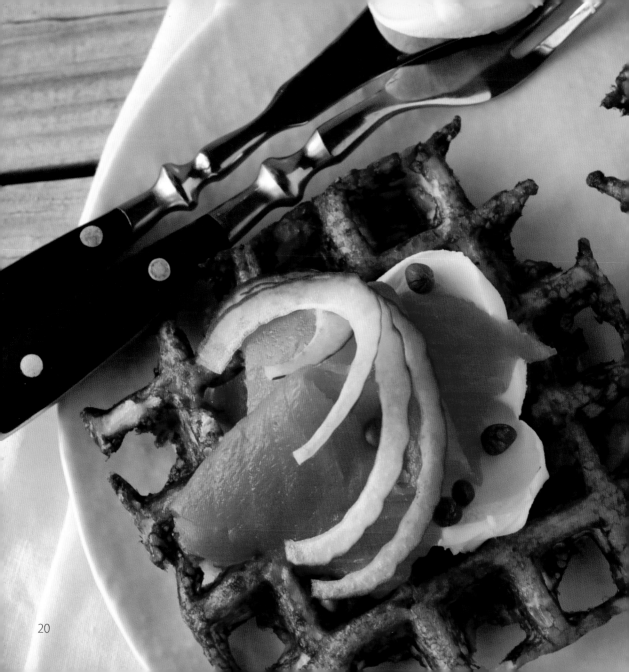

20

breads and breakfast

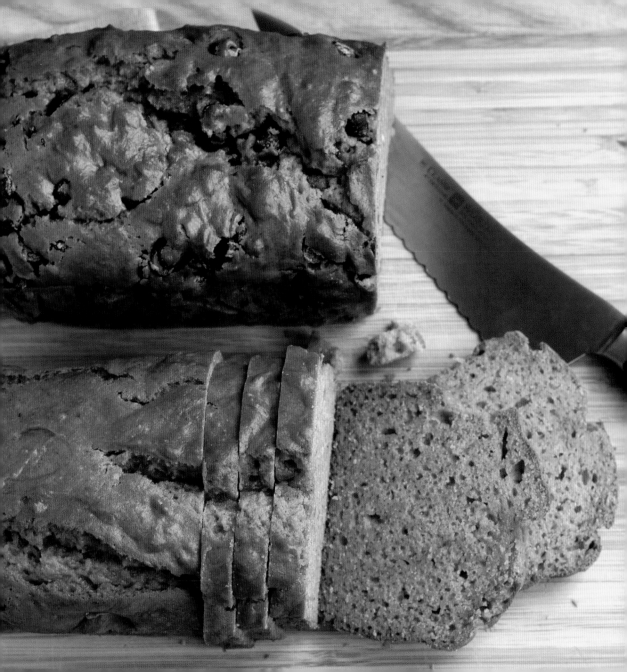

Pumpkin Bread

My daughter Emily enjoys making pumpkin bread, and this simple, spiced version is her favorite. Julie Tribble, our doula, brought over a loaf of this bread, along with the recipe, right after Emily was born —maybe that's why she loves it! Plain pumpkin bread is a favorite family breakfast when it's sliced, toasted, and spread with cream cheese. This recipe makes two loaves. To keep it interesting, leave one loaf plain and stir some chocolate chips or nuts into the second loaf.

makes 2 loaves

INGREDIENTS

3½ cups all-purpose flour
2 teaspoons baking soda
1½ teaspoons salt
1 teaspoon ground cinnamon
1 teaspoon ground nutmeg
2 cups sugar
1 cup vegetable oil
4 large eggs
⅔ cup milk or water
1 (15-ounce) can pumpkin
1 cup chocolate chips (optional)

Preheat oven to 350°. Line 2 (9x5-inch) loaf pans with nonstick or greased aluminum foil.

Combine flour, soda, salt, cinnamon, and nutmeg in a large bowl.

Beat together sugar, oil, eggs, milk, and pumpkin in a separate bowl; stir into flour mixture. Spoon into prepared loaf pans.

Bake 1 hour or until bread is done in center when tested with a wooden skewer or toothpick.

Cool in pans on a wire rack for 10 minutes. Remove from pans and cool completely.

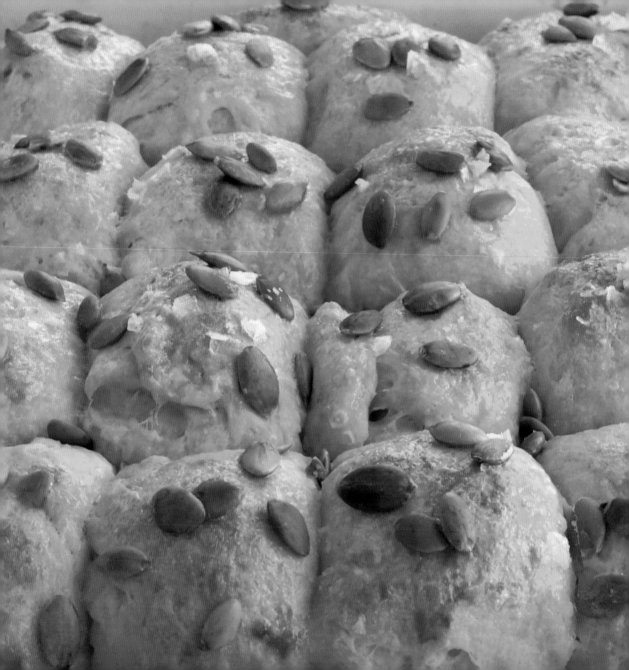

Pumpkin-and-Pepita Parker House Rolls

· ·

Allow the cream, egg, and butter to reach room temperature before mixing together because cold ingredients will slow down the rising process.

· ·

makes 1½ dozen

INGREDIENTS
7 tablespoons butter, divided
½ cup pumpkin or butternut
 squash puree
1 cup cream, half-and-half, or
 whole milk
2 large eggs, divided
¼ cup sugar
3½ cups all-purpose flour
1 envelope (2½ teaspoons)
 active dry yeast
1½ teaspoons salt
Pepitas (roasted pumpkin seeds)
Flaky sea salt

Melt 4 tablespoons butter.

In the bowl of a stand-up electric mixer, beat 4 tablespoons melted butter, pumpkin puree, cream, 1 egg, sugar, flour, yeast, and salt, mixing until a dough forms. Knead on a lightly floured surface (or in mixing bowl with a dough hook) about 5 minutes or until smooth. Transfer to a lightly oiled bowl, turning to coat surface. Cover loosely with plastic wrap and let rise in a warm place for 1 to 2 hours or until doubled in bulk.

Melt remaining 3 tablespoons butter. Brush a 9x9-inch baking dish lightly with some of the melted butter. Set aside.

Punch dough down and divide into 18 pieces on a floured surface. Roll into balls, and place in prepared baking dish. Brush tops with remaining melted butter. Cover with plastic wrap and let rise in a warm place for 45 minutes or until puffed (but not doubled in size).

Preheat oven to 350°. Whisk remaining egg and brush over tops of rolls. Sprinkle with desired amount of pepitas and sea salt. Bake 20 to 25 minutes or until golden brown.

25

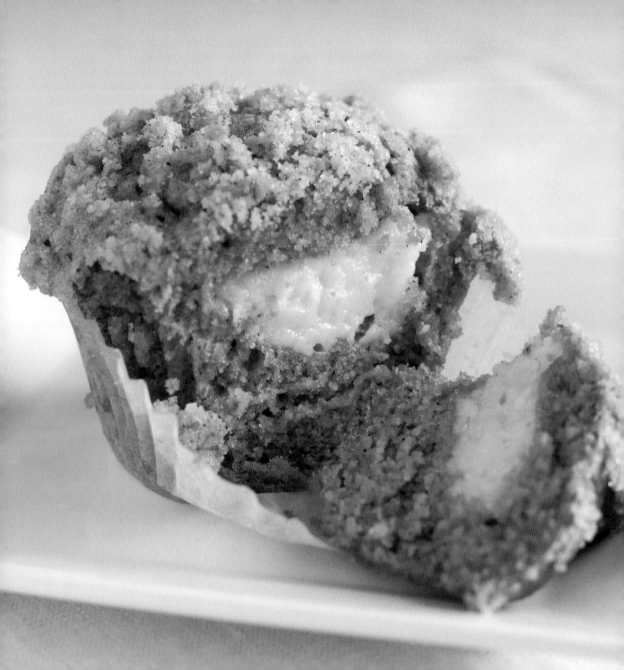

Pumpkin-Cream Cheese Streusel Muffins

This delicious treat is my go-to when I need to bring a breakfast snack but have no time to run to the store. I always keep a couple of packages of cream cheese in the fridge, and the dry goods have dedicated space in the pantry. It might seem a little fussy to make a muffin with a creamy center, but it's super easy. If you use paper liners, you don't have to be that careful with the layering to get great results that pop out of the pan.

makes 2 dozen

INGREDIENTS

8 ounces cream cheese, softened
2½ cups sugar, divided
1 teaspoon vanilla extract
4 eggs, divided
3⅓ cups all-purpose flour, divided
4 teaspoons ground cinnamon, divided
4 tablespoons butter
⅓ cup chopped pecans
1 teaspoon ground cloves
½ teaspoon ground nutmeg
½ teaspoon ground ginger
1 teaspoon baking soda
1 teaspoon salt
1 (15-ounce) can pumpkin or butternut squash
1 cup vegetable oil

Combine cream cheese, ½ cup sugar, vanilla, and 1 egg in a small bowl; set aside. In a separate small bowl, combine ½ cup sugar, ⅓ cup flour, and 1 teaspoon cinnamon; cut in butter with a pastry blender or fork until large crumbs form. Stir in pecans. Set aside.

Preheat oven to 375°. Line 2 (12-cup) muffin pans with paper liners.

Combine remaining 3 cups flour, remaining 3 teaspoons cinnamon, cloves, nutmeg, ginger, baking soda, and salt in a large bowl.

In a separate large bowl, whisk together remaining 3 eggs, remaining 1½ cups sugar, pumpkin, and oil. Add to flour mixture, stirring just until moistened. Spoon half of batter into prepared muffin pans. Dollop cream cheese mixture evenly over batter in pans, and top evenly with remaining batter. Sprinkle with pecan mixture.

Bake 20 minutes. Remove from pan; cool on a wire rack.

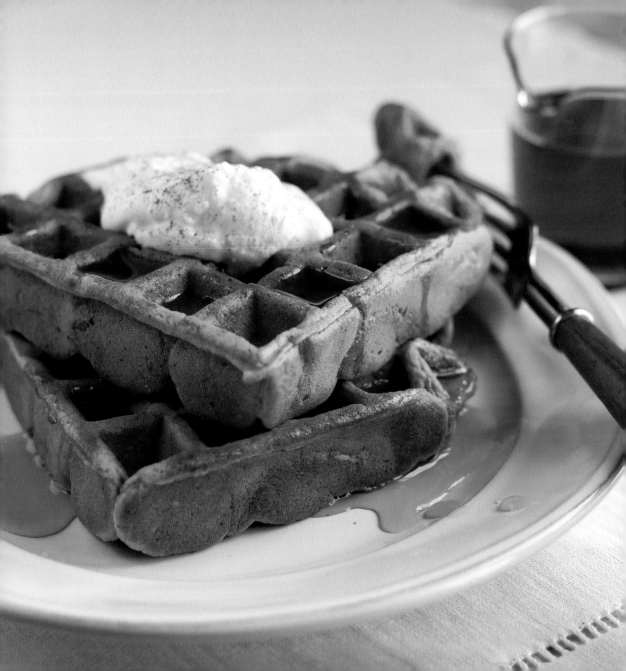

Pumpkin Waffles

· ·

The amount of batter you use for each waffle depends on the size and shape of your waffle maker.
I use a family-size one that makes four thick, Belgian-style waffles at one time. You may get more if you use
a thin waffle iron, and they will take less time to cook and brown up. Be sure not to peek at the waffle,
especially if it is still steaming. Of course, the first waffle may be a throwaway if you are testing for time.
If you are feeling creative, sprinkle your waffles with blueberries or chocolate chips before or after cooking.

· ·

makes 8 waffles

INGREDIENTS
2 cups all-purpose flour
2 teaspoons baking powder
2 teaspoons ground cinnamon
1 teaspoon salt
½ teaspoon soda
½ teaspoon ground ginger
¼ teaspoon ground cloves
3 large eggs
1 (15-ounce) can pumpkin
½ cup packed light brown sugar
1½ cups buttermilk or milk
3 tablespoons oil
Maple syrup
Sweetened whipped cream

Preheat waffle iron.

Combine flour, baking powder, cinnamon, salt, soda, ginger, and cloves in a large bowl.

Whisk together eggs, pumpkin, brown sugar, and buttermilk in a medium bowl. Add egg mixture to flour mixture, stirring gently until a moist batter forms.

Brush waffle iron with oil or spray with nonstick cooking spray, if necessary. For each 4-inch waffle, spoon about ¼ cup batter (or more, depending on size of waffle iron) into iron. Cook 3 to 5 minutes or until cooked through. Serve with maple syrup and sweetened whipped cream.

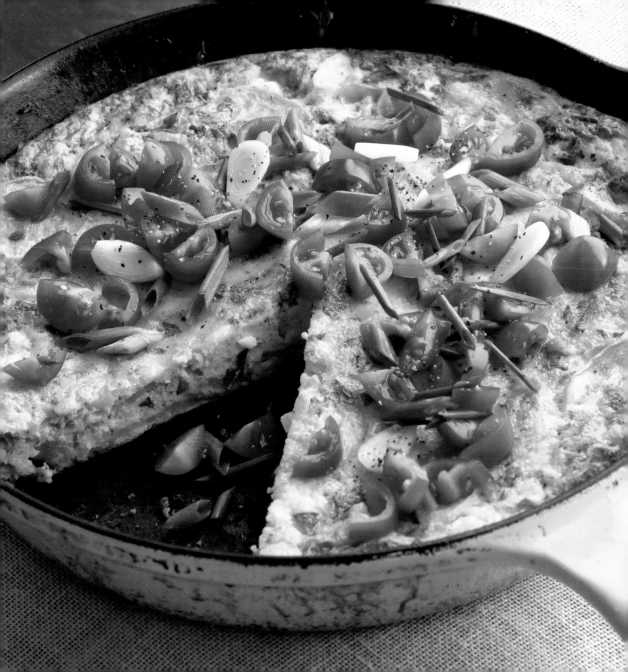

Southwestern Summer Squash Frittata

Eggs are eaten just about every day at our house because we have a yard filled with free-range chickens! Over easy or omelets are our standard go-tos, but when we have company or a leisurely weekend, frittatas are a flavorful treat. They are great for company because you can pop one in the oven, then tend to other things (like making coffee) without distraction.

makes 4 servings

INGREDIENTS

8 large eggs
¼ cup milk
1 teaspoon salt
½ teaspoon freshly ground
 black pepper
½ cup crumbled feta cheese
¼ cup chopped fresh cilantro
3 tablespoons butter or olive oil
2 small zucchini, thinly sliced
 or 1 large zucchini, halved
 and sliced
½ small onion, finely chopped
1 teaspoon ground cumin
2 plum tomatoes, seeded
 and chopped
3 green onions, chopped

Preheat oven to 375°.

Whisk together eggs, milk, salt, and pepper in a large bowl. Stir in feta and cilantro. Set aside.

Melt butter in a large cast iron or oven-safe skillet. Add zucchini, onion, and cumin. Cook, stirring occasionally, for 10 to 12 minutes or until vegetables are tender.

Pour egg mixture over vegetables and cook 2 minutes or until eggs are just beginning to set.

Place skillet in oven and bake 10 to 12 minutes or until puffed around the sides and just set in the middle. Top each serving with tomatoes and green onions.

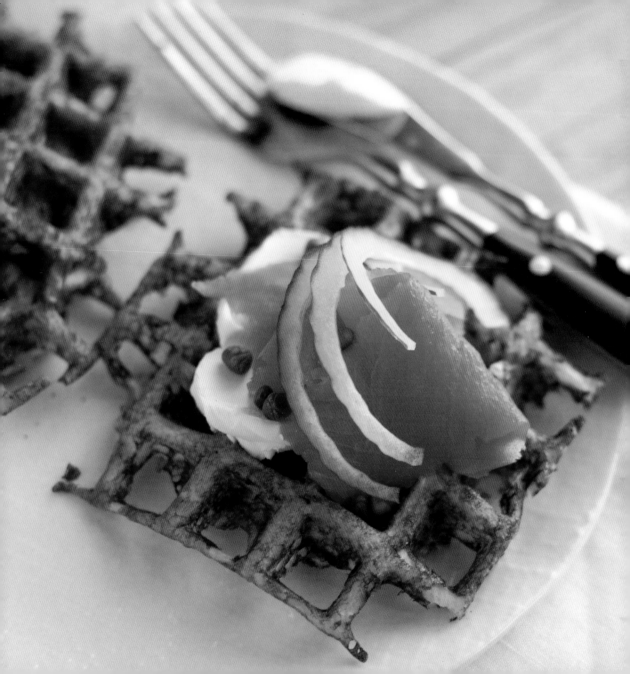

Zucchini Waffle Fritters

Cooking this hybrid fritter-latke-pancake in a waffle iron ensures lots of crispy texture and a quickly cooked center. If desired, heat a thin layer of olive oil in a nonstick pan over medium-high heat. Scoop about ⅓ cup mixture into oil and flatten with a spatula. Cook on both sides until golden brown.

makes 4 to 6 servings

INGREDIENTS

3 cups finely grated zucchini and/or yellow squash (about 3 medium)
1 teaspoon salt, divided
3 large eggs
½ sweet onion, finely chopped
1 cup shredded mozzarella cheese
¾ cup shredded Parmesan cheese
Olive oil

TOPPINGS

Crème fraiche, mascarpone, or sour cream; smoked salmon; capers; sliced red onion; cracked black pepper

Toss zucchini with ½ teaspoon salt; let stand 10 minutes. Drain zucchini on paper towels or a clean kitchen towel, squeezing out excess moisture.

Preheat waffle iron.

Beat eggs in a large bowl. Stir in zucchini, onion, cheeses, and remaining ½ teaspoon salt.

Brush waffle iron with olive oil or spray with nonstick cooking spray, if necessary. Scoop about ⅓ cup zucchini mixture for each fritter. Close lid and cook about 5 minutes or until crisp and cooked through.

Serve fritters with desired toppings.

salads, sides, small bites

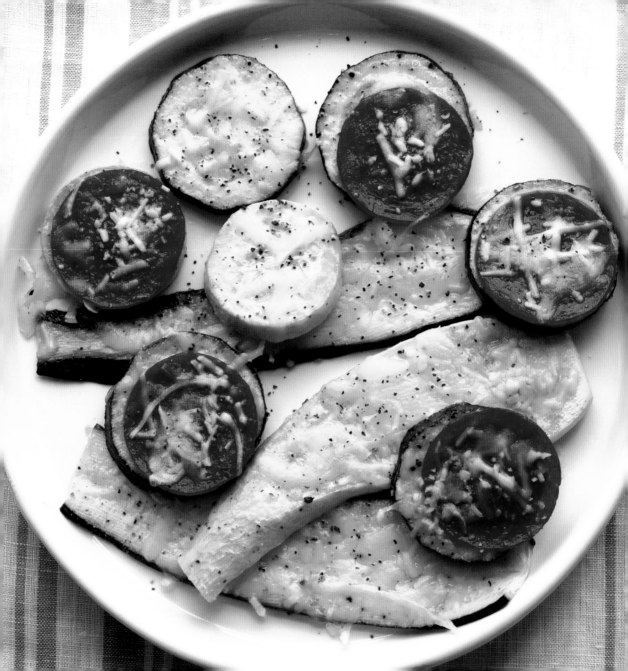

Zucchini Bites and Planks

My daughter Corinne made this appetizer for a school project and now it's a family favorite (and who doesn't encourage schoolwork that feeds everyone?!). Her version is vegetarian, but the rest of the family adds a slice of pepperoni or chopped prosciutto on top.

makes 4 to 6 servings

INGREDIENTS
2 zucchini or yellow squash
Olive oil
Salt, to taste
Coarsely ground black pepper, to taste
¼ teaspoon garlic powder
Sliced pepperoni or chopped prosciutto (optional)
½ cup shredded Parmesan cheese
½ cup shredded mozzarella cheese

Preheat oven to 350°.

Slice zucchini into ½-inch-thick rounds or ¼-inch-thick planks. Place on a baking sheet lined with nonstick aluminum foil or a silicone baking mat.

Brush tops lightly with olive oil, and sprinkle with salt, pepper, and garlic powder. Top slices with pepperoni, if desired.

Bake 5 to 8 minutes or until almost tender. Remove from oven and sprinkle with cheeses. Bake 5 more minutes or until cheeses melt. If desired, broil 1 to 2 minutes for golden tops.

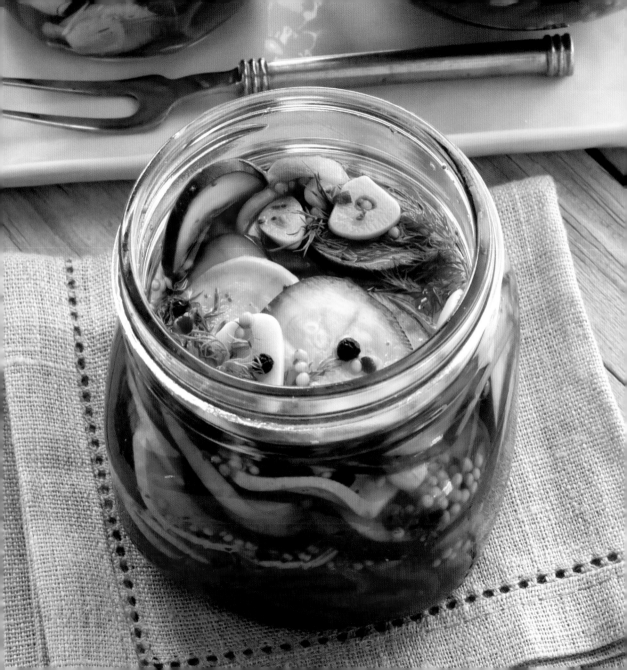

Summer Squash Pickles

Because these zesty snacks are not traditionally canned in a boiling-water bath, they don't have the same storage time and must be kept in the refrigerator. The good news is that you don't have to stress too much about what you store them in—you can use a variety of glass jars. I just use whatever is clean and handy.

makes 6 cups

INGREDIENTS

2 zucchini
2 yellow squash
1 red onion
2 tablespoons kosher salt or other non-iodized salt
3 to 4 fresh dill sprigs
2 cups apple cider vinegar or white vinegar
½ cup sugar
5 small garlic cloves, peeled
½ teaspoon crushed red pepper flakes
1 tablespoon mustard seeds
1 teaspoon celery seeds
¼ teaspoon black peppercorns

Cut squash and onion into ⅛-inch slices. Place in a large bowl. Add salt, tossing to coat. Let stand 1 hour. Transfer to a colander; rinse and drain well.

Divide squash and onion into 3 (1-pint) canning jars. Place dill sprigs evenly in jars.

Combine vinegar, sugar, garlic, and crushed red pepper flakes in a small saucepan over medium heat. Cook 2 minutes, stirring constantly, until sugar dissolves. Stir in mustard seeds, celery seeds, and peppercorns. Bring to a boil and carefully pour hot brine into jars, leaving about ½ inch of space at the top. Secure lids and shake gently.

Cool jars to room temperature. Refrigerate 3 days before serving. Store in refrigerator up to 2 months.

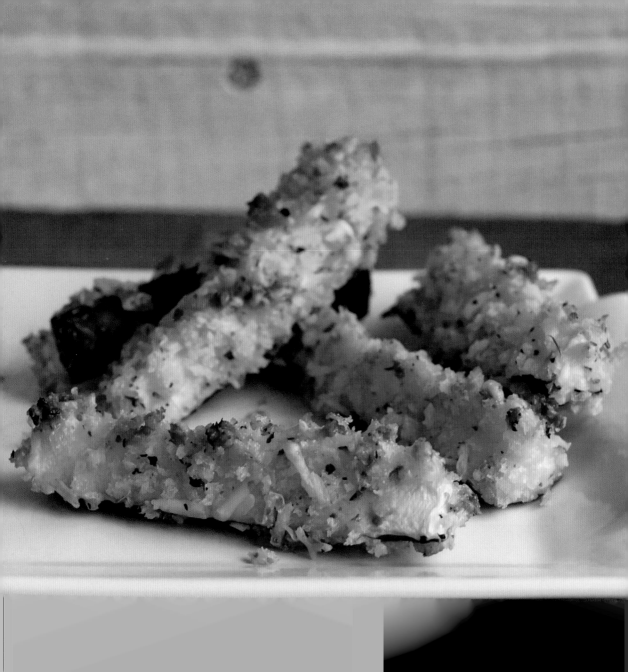

Baked Parmesan-Zucchini Fries

These crispy snacks are addictive!

makes 4 servings

INGREDIENTS
¼ cup all-purpose flour
2 large eggs
1 cup panko breadcrumbs
½ cup finely shredded
 Parmesan cheese
2 teaspoons Italian seasoning
¼ teaspoon garlic powder
¼ teaspoon salt
⅛ teaspoon freshly ground
 black pepper
2 medium zucchini

Preheat oven to 425°. Line a baking sheet with nonstick or lightly greased aluminum foil.

Place flour in a zip-top plastic bag; set aside.

Whisk together eggs in a shallow bowl; set aside.

Combine panko, cheese, seasoning, garlic powder, salt, and pepper in a shallow bowl; set aside.

Cut zucchini in half crosswise, then cut each half into wedges.

Add a few pieces of zucchini to flour; seal and toss to coat. Dredge zucchini in eggs, then dredge in panko mixture. Place on baking sheet and repeat procedure with remaining zucchini, flour, eggs, and panko mixture.

Bake 20 minutes or until tender. For extra-crispy fries, broil 3 to 4 minutes or until golden brown.

Battered and Fried Zucchini

Frying summer squash was the first, and sometimes only, successful way to get my kids to eat it when they were young. Often you see it with a coarse, cornmeal crust, which admittedly has a crunchy texture, but my kids would only go for the smooth tempura-style batter below. It's pretty yummy dipped in Ranch dressing or warm marinara sauce, but we like it with a sprinkling of salty Parmesan cheese. If you have batter left, try it with extremely thin-sliced sweet onions for an amazing treat.

makes 12 servings

INGREDIENTS
1 cup all-purpose flour
1 teaspoon salt
1 teaspoon sugar
¾ teaspoon baking powder
1 teaspoon Italian seasoning
½ teaspoon garlic powder
1 cup milk
2 egg whites
2 teaspoons hot sauce
2 medium zucchini or
 yellow squash
Vegetable oil
Shredded Parmesan cheese

Whisk together flour, salt, sugar, baking powder, Italian seasoning, and garlic powder in a large bowl. Whisk in milk, egg whites, and hot sauce.

Slice zucchini into ⅛- to ¼-inch-thick rounds.

Pour oil ½- to 1-inch deep in a large saucepan over medium-high heat. Heat to 375°.

Dip a few slices of zucchini into batter until covered. Remove with a fork, letting excess batter drip back into bowl. Fry until golden brown on both sides. Drain on paper towels. Sprinkle with cheese.

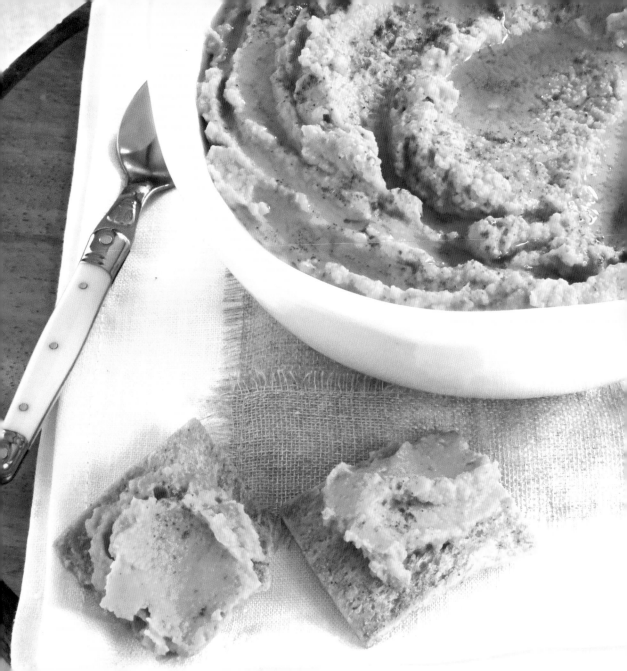

Pumpkin Hummus

There are lots of hummus flavors in stores and you can easily make this unique fresh version anytime with ingredients kept in the pantry. The pumpkin flavor is a fun riff you can serve at Halloween parties and through the rest of the fall holidays.

makes 3 cups

INGREDIENTS
1 (15-ounce) can pure pumpkin
1 (15-ounce) can garbanzo
 beans, rinsed and drained
½ teaspoon grated lemon zest
⅓ cup fresh lemon juice
⅓ cup tahini
1 garlic clove, sliced
2 tablespoons olive oil
1½ teaspoons ground cumin
1 teaspoon salt
¼ teaspoon smoked paprika or
 ground cayenne pepper
Pita chips

GARNISH
toasted pumpkin seeds

Combine pumpkin, beans, lemon zest and juice, tahini, garlic, oil, cumin, salt, and paprika in a food processor; process until smooth.

Spoon into a serving bowl; garnish, if desired. Serve with pita chips.

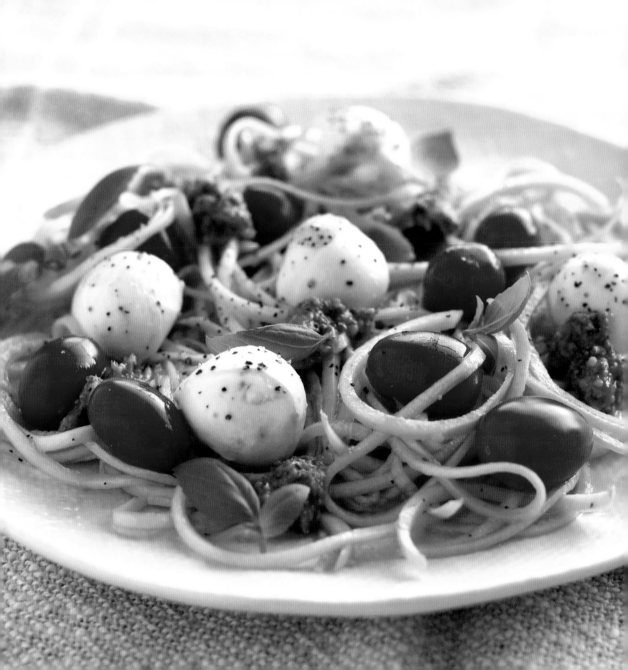

Zoodle Caprese Salad

Zucchini noodles, also called "zoodles," are a popular gluten-free substitution for pasta but are also great for raw squash dishes. If you don't like the firm texture of raw zucchini, you can cook them for a minute or two, but don't overdo it or they'll get mushy.

makes 4 servings

BALSAMIC DRESSING
½ cup extra virgin olive oil
3 tablespoons balsamic vinegar
1 small shallot, minced
1 teaspoon Dijon mustard
1 teaspoon honey
Salt and pepper, to taste

SALAD
2 medium-size yellow or
 zucchini squash (1 pound)
1 (8-ounce) container fresh
 mini mozzarella balls
1 pint cherry tomatoes
⅓ cup prepared refrigerated
 basil pesto
¼ cup fresh basil leaves, slivered

To make dressing, whisk together olive oil, vinegar, shallot, mustard, honey, salt, and pepper in a small bowl.

To make salad, cut ends from squash and cut into noodles using a spiralizer.

Toss in a serving bowl with a few tablespoons dressing. Add mozzarella and tomatoes. Dollop with pesto and top with basil leaves. Drizzle with additional balsamic dressing, as desired.

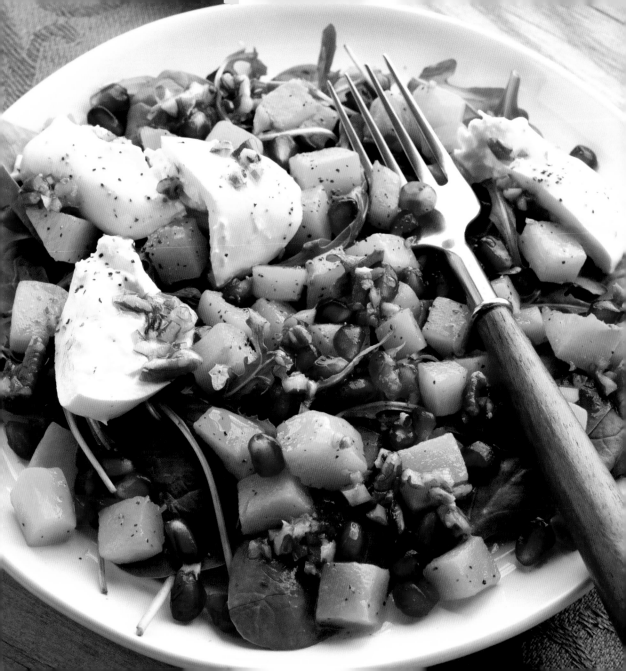

Roasted Winter Squash-and-Pomegranate Salad

Mix it up by substituting any type of winter squash—try sliced delicata or acorn squash rings. Hard-skin squashes like butternut, kabocha, or Hubbard should be peeled first.

makes 6 servings

INGREDIENTS

4 to 4½ cups cubed kabocha, butternut, or other winter squash
2 tablespoons olive oil
½ teaspoon salt
¼ teaspoon coarse-ground black pepper
3 cups baby spinach
3 cups baby arugula
½ cup pomegranate seeds
1 (8-ounce) container burrata or fresh mozzarella, cut into pieces
Pecan Vinaigrette (recipe at right)

Preheat oven to 350°. Toss squash in olive oil, salt, and pepper. Place in a single layer on a baking sheet. Roast 20 minutes or until squash is tender but still holds it shape.

Combine spinach and arugula on a serving platter or individual plates. Top evenly with squash, pomegranate seeds, and cheese. Drizzle with Pecan Vinaigrette to taste.

Pecan Vinaigrette: Preheat oven to 350°. Place **½ cup pecan halves** in a single layer on a baking sheet. Bake 8 minutes or until toasted and fragrant. Watch carefully to avoid burning. Cool slightly and finely chop. Whisk together **¼ cup champagne or white wine vinegar; 2 tablespoons pure maple syrup; 1 shallot, minced, or 3 tablespoons sweet onion; 1 teaspoon Dijon mustard; and ½ teaspoon salt.** Slowly whisk in **½ cup extra virgin olive oil.** Whisk in pecans. Makes 1 cup.

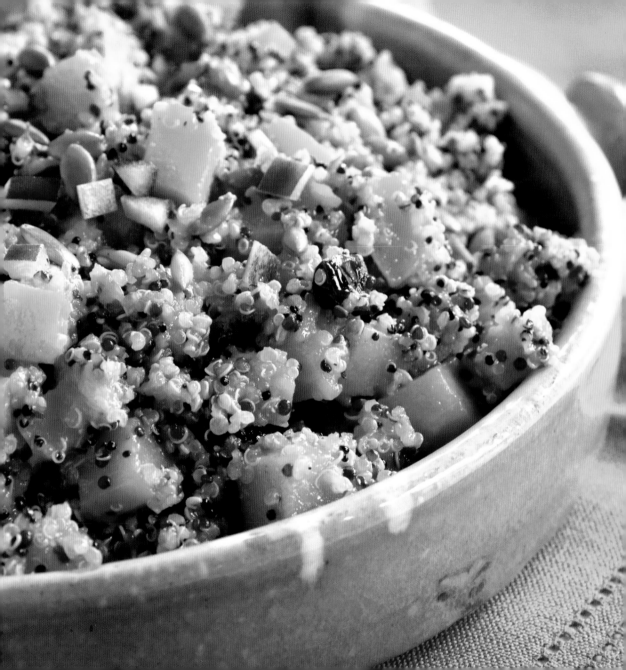

Butternut Squash-and-Quinoa Salad

I put this in the salad chapter, but it's rich enough to be an entire meal. If you really want to take this into main-dish territory, add a cup or two of shredded rotisserie chicken to the mix. Quinoa is an ancient whole grain, gluten-free and filled with lots of protein. When it's done, you'll see the germ separates and curls around the seed.

makes 4 to 6 servings

INGREDIENTS

5 cups diced butternut squash
2 tablespoons olive oil
1 teaspoon salt
1 cup plain or tricolor quinoa
2 cups vegetable or chicken broth
½ cup dried cranberries
⅓ cup toasted pepitas
 (pumpkin seeds) or walnuts
⅓ cup chopped red onion
Honey-Thyme Vinaigrette
 (recipe at right)

Preheat oven to 400°.

Toss squash with oil and sprinkle with salt. Place squash on a baking sheet. Bake 15 to 20 minutes or until tender.

Rinse quinoa under running water in a wire sieve. Bring broth to a boil in a medium saucepan. Stir in quinoa. Cover and cook 15 to 20 minutes or until tender and broth is mostly absorbed. Let stand, covered, for 5 minutes. Drain if any liquid pools at bottom of pan. Fluff with a fork.

Combine butternut, quinoa, cranberries, pepitas, and onion in a large serving bowl. Drizzle with desired amount of vinaigrette, tossing to combine.

Honey-Thyme Vinaigrette: Whisk together **¼ cup apple cider vinegar; 1 teaspoon Dijon mustard; 1 tablespoon honey; 1 small garlic clove, minced; 2 teaspoons chopped fresh thyme; ½ teaspoon salt; ¼ teaspoon coarsely ground black pepper; and ⅓ cup extra virgin olive oil** in a bowl until well blended. Makes about ¾ cup.

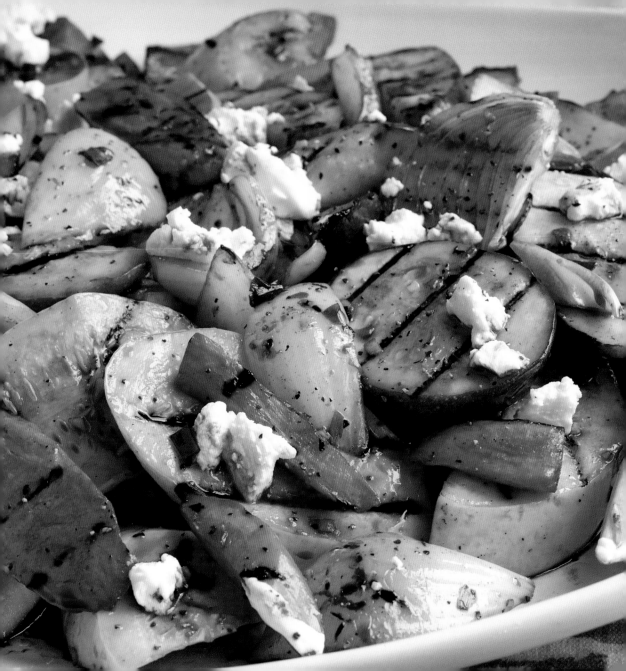

Grilled Squash Salad

Serve this amazing side dish with grilled chicken, barbecue ribs, or even pizza. The veggies taste better after the second soaking in the vinaigrette. Dark vinegar will stain them, but they will be good in the refrigerator for a few days.

makes 8 to 10 servings

VINAIGRETTE
½ cup balsamic, white balsamic, or white wine vinegar
¼ cup extra virgin olive oil
2 garlic cloves, minced
1 tablespoon each chopped basil, parsley, and chives
2 teaspoons molasses
½ teaspoon salt
¼ teaspoon coarsely ground black pepper

SALAD
2 medium-size zucchini
2 yellow squash
2 carrots
1 large sweet onion
½ cup crumbled goat cheese (optional)

To make vinaigrette, combine vinegar, oil, garlic, herbs, molasses, salt, and pepper in a 13x9-inch baking dish or other large container. Cut zucchini, squash, carrots, and onions into large pieces. Add to vinaigrette, tossing to coat. Let marinate 30 to 60 minutes.

Preheat grill to medium-hot or prepare charcoal for medium-hot coals.

Drain zucchini mixture, reserving liquid. Grill, turning occasionally, until crisp-tender. Return to reserved liquid. Serve warm or refrigerate until ready to serve. Sprinkle with goat cheese, if desired. Drizzle with reserved vinaigrette, if desired.

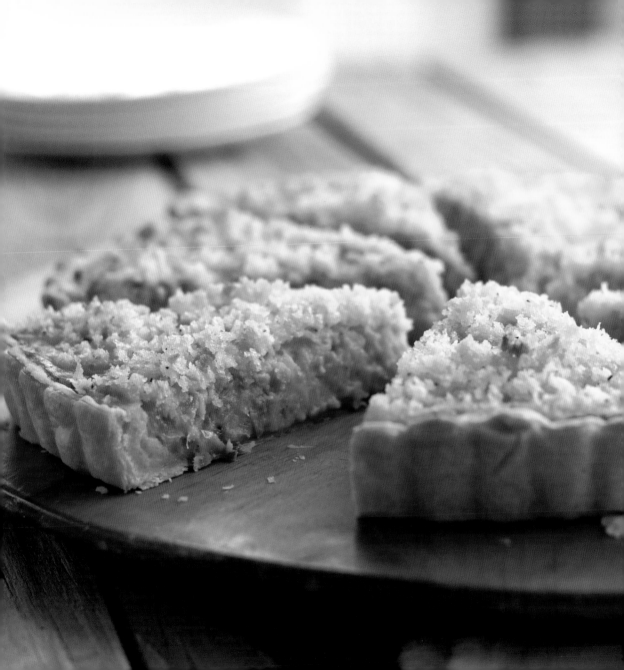

Winter Squash-and-Onion Tart

About 20 years ago I came across a similar recipe in *Food & Wine* magazine when I was looking for a Thanksgiving dish to shake up the traditional fare. I loved the unique combination of flavors, and while it tastes about the same, I've made a lot of changes, particularly ones that save time when my cooktop and oven are filled. If you want it more from scratch, use your own homemade pastry and roast (then puree) a 1¼-pound butternut squash.

makes 8 servings

INGREDIENTS

3 tablespoons butter, divided
1 large sweet onion, halved
 and sliced
1 refrigerated piecrust
2 cups mashed or pureed
 butternut squash (from
 about 1 pound cubed)
2 large eggs
½ cup (2 ounces) grated Havarti,
 fontina, or Gouda cheese
¼ cup shredded Parmesan cheese
2 ounces soft goat
 cheese, crumbled
1 teaspoon chopped
 fresh rosemary
½ teaspoon salt
¼ cup panko breadcrumbs
¼ teaspoon freshly ground
 black pepper

Melt 2 tablespoons butter in a skillet over medium heat. Add onion and cook 30 to 35 minutes or until golden brown and very tender. Set aside.

Preheat oven to 375°. Unfold piecrust and fit into a 9½-inch tart pan with removable bottom. Line the bottom with aluminum foil, and fill with pie weights, uncooked rice, or dried beans. Bake 15 minutes. Remove foil and weights; bake 5 more minutes.

If using cooked cubed butternut squash, mash until smooth. Whisk in eggs, cheeses, rosemary, and salt. Stir in onion. Spread squash mixture into pastry.

Melt remaining 1 tablespoon butter. Stir in panko and pepper. Sprinkle over squash. Bake 40 minutes or until golden brown and set. Cool 5 minutes before slicing.

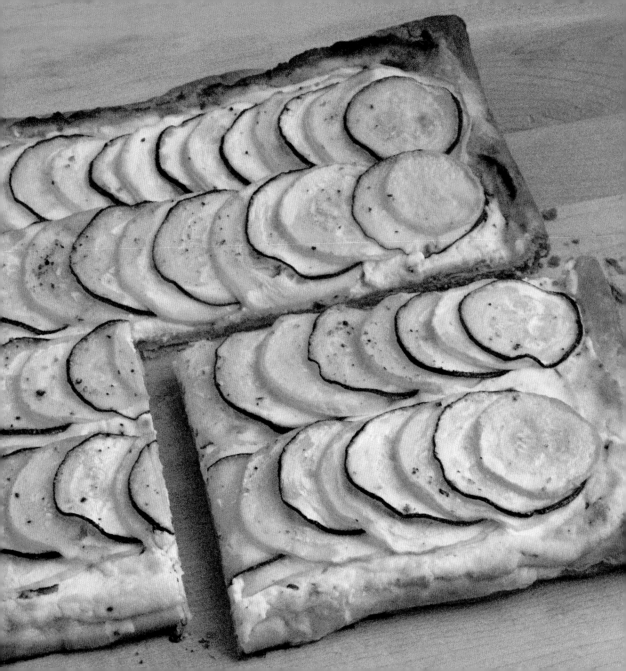

Summer Squash Tart

This is one of my favorite recipes for summer squash, and I'll eat it with a side salad as a light summer meal. Prebaking the puff pastry is important for a crispy crust, but it's easy. The rack is put on top to keep it fairly flat as it bakes.

makes 8 to 10 appetizer, 6 side-dish, or 4 entrée servings

INGREDIENTS

- 1 (17.24-oz.) package puff pastry, thawed if frozen
- 2 large zucchini or yellow squash
- 1½ cups ricotta cheese
- ½ teaspoon lemon zest
- 2 teaspoons fresh lemon juice
- 1 small garlic clove, minced
- 1 tablespoon minced fresh basil
- ½ teaspoon salt
- ¼ teaspoon coarsely ground black pepper
- 2 to 3 teaspoons extra virgin olive oil

Preheat oven to 400°.

Unroll puff pastry on a parchment paper-lined baking sheet. Cover with parchment and place a wire cooling rack on top. Bake 15 minutes or until almost cooked through. Remove rack and parchment; set aside.

Cut squashes into very thin, ⅛- to ¼-inch-thick slices. Set aside.

Stir together ricotta, zest, juice, garlic, basil, salt, and pepper in a bowl. Spread ricotta mixture evenly over partially cooked pastry.

Layer squash slices over top of ricotta mixture. Brush with olive oil. Bake 20 to 30 minutes or until edges are golden brown and squash is tender.

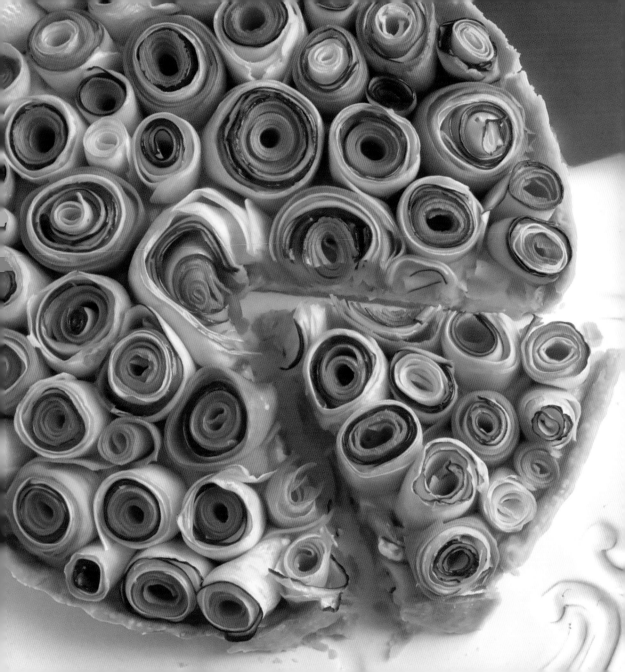

Carrot-Summer Squash Spiral Tart

This spectacular tart makes a big impression, but the wow factor comes at a cost—twisting the squash and carrot strips into rosettes is time-consuming and tedious. Be sure to get a helper!

makes 8 servings

INGREDIENTS

1 refrigerated piecrust
 (or homemade)
2 carrots
3 small zucchini
3 small yellow squash
2 teaspoons butter
1 shallot, minced
1 (8-ounce) package
 cream cheese
⅓ cup shredded
 mozzarella cheese
¼ cup shredded Parmesan cheese
½ teaspoon salt
¼ teaspoon coarsely
 ground black pepper
½ cup heavy cream or milk
1 tablespoon olive oil

Preheat oven to 375°. Fit piecrust into a 9-inch tart pan with removable bottom. Prick with a fork and top with parchment paper or aluminum foil. Add pie weights, dry rice, or dried beans to fill about ⅔ full. Bake 20 minutes. Lift out parchment; remove weights. Return to oven and bake 5 more minutes or until pale golden brown and just barely cooked. Set aside.

Slice carrots, zucchini, and yellow squash into long ribbons using a vegetable peeler. Microwave carrots 2 to 3 minutes or until tender but still firm. Microwave squashes 2 minutes or until slightly tender. Set aside.

Melt butter in a large skillet over medium-low heat. Add shallot and cook, stirring frequently, until tender. Reduce heat to low. Add cream cheese. Cook, stirring frequently, until smooth. Stir in cheeses, salt, and pepper, stirring until melted and smooth. Stir in cream. Spread cheese mixture in bottom of crust.

Roll carrots and squash into spirals, about 1 to 2 inches wide. Arrange in tart, pressing into cheese mixture to keep upright.

Brush spirals with olive oil. Bake 40 minutes or until vegetables are tender.

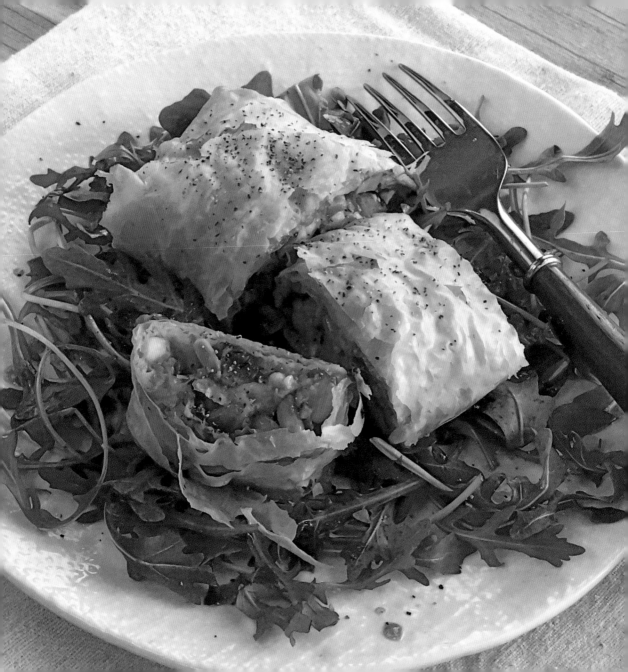

Zucchini-and-Mushroom Strudel

Handling phyllo isn't as tricky as it seems. And this recipe doesn't use an entire roll of the paper-thin dough, so if some pieces tear apart, you'll have extras. If you are looking for something to do with the extra sheets of phyllo, brush each with butter, then sprinkle with seasoned salt and herbs. Layer a few sheets together and cut into squares or triangles. Bake and use as a topper for soup or as croutons for salad.

makes 6 to 8 servings

INGREDIENTS

3 small zucchini
 (1 pound), grated
1 teaspoon salt, divided
2 tablespoons plus ⅓ cup
 butter, divided
8 ounces cremini or button
 mushrooms, sliced
½ small sweet onion
1 teaspoon chopped fresh thyme
 or ½ teaspoon dried thyme
½ cup finely chopped pine nuts
 or walnuts
¾ cup crumbled feta cheese
3 tablespoons plain
 dry breadcrumbs
¼ teaspoon coarsely ground
 black pepper
10 sheets frozen and thawed
 phyllo dough

Combine zucchini and ½ teaspoon salt in a colander to drain. Let stand 20 to 30 minutes, pressing to squeeze out liquid. Melt 2 tablespoons butter in a large skillet over medium-high heat. Add mushrooms, onion, and thyme. Cook 10 minutes, stirring frequently, until mushrooms are tender. Add drained zucchini and pine nuts to mushroom mixture. Cook, stirring constantly, 1 to 2 minutes. Remove from heat. Stir in cheese and breadcrumbs. Add remaining ½ teaspoon salt and pepper.

Preheat oven to 400°. Line a baking sheet with parchment paper, greased aluminum foil, or a silicone baking mat. Melt remaining ⅓ cup butter. Place one sheet of phyllo on a work surface. Brush sheet lightly with butter. Repeat with 4 additional phyllo sheets and butter, stacking sheets on top of each other.

Spoon half of zucchini filling in a line down the center, leaving a 2-inch border on each side. Roll one side of phyllo over filling, then roll entire bundle; place, seam-side down, on baking sheet. Brush with butter and tuck ends under roll. Repeat with remaining phyllo and filling to create 2 strudels.

Bake 20 to 25 minutes or until golden brown. Let stand 5 minutes before slicing. Serve over greens with desired dressing.

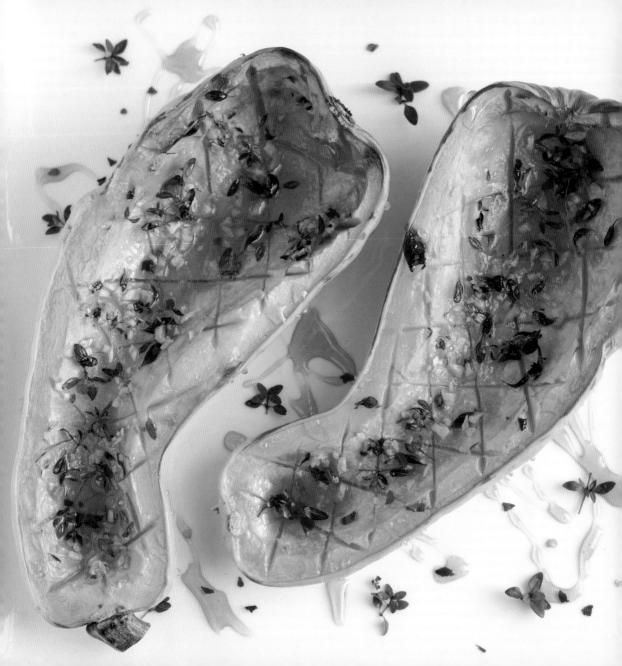

Sweet-and-Spicy Roasted Delicata

When halved, long and skinny delicata squash is fairly shallow. You can substitute acorn squash, red kuri, or honeynut, but baste occasionally during baking because the oil mixture will pool in the center.

makes 4 servings

INGREDIENTS
2 delicata squash, halved
 and seeded
1 tablespoon olive oil
¼ teaspoon salt
1 teaspoon garlic, minced
1 teaspoon fresh thyme leaves
3 tablespoons honey

Preheat oven to 425°.

Cut inside of squash into a crosshatch pattern. Place on a baking sheet, cut side up.

Combine oil, salt, garlic, and thyme. Brush over cut surfaces and bake 20 minutes or until fork-tender.

Drizzle with honey before serving.

Sesame-Miso Squash

The Queensboro restaurant in Jackson Heights, New York, served this dish one cold winter evening, and I became obsessed with the sweet and salty flavors coating the earthy squash. I don't really know their recipe, but I created this one so I could enjoy a similar version at home anytime. Miso paste is key to this recipe; luckily, you can find it with increasing ease in the international sections of markets and big-box stores. And lucky for everyone, you can use a tablespoon or two of regular soy sauce for a tasty substitution, but the mixture will not have the same thick texture.

makes 4 servings

INGREDIENTS
1 large acorn, large delicata, or
 small butternut squash
1 tablespoon sesame oil
⅓ cup white or yellow
 miso paste
2 tablespoons maple syrup
2 tablespoons butter, softened
½ teaspoon rice vinegar

GARNISH
chopped fresh celery leaves

Preheat oven to 400°.

Cut squash in half and scoop out seeds. (Acorn and delicata skin is edible, but peel butternut if using.) Cut halves into large pieces and toss in sesame oil. Place on an aluminum foil-lined baking sheet and bake 35 minutes or until tender.

Stir together miso paste, syrup, butter, and vinegar in a small bowl.

Remove squash from oven and brush with miso mixture. Return to oven and bake 10 more minutes or until sticky and golden brown. Garnish, if desired.

Squash-and-Onion Casserole

The flavor of this simple and old-fashioned casserole is mild—you can jazz
it up by adding sliced jalapeños to the squash-and-onion mixture.

makes 6 servings

INGREDIENTS

1 tablespoon olive oil
6 yellow squash, thinly sliced
 (about 2½ pounds)
1 small onion, chopped
1 large egg, lightly beaten
½ cup regular or light
 sour cream
1 cup (4 ounces) shredded
 Cheddar cheese
½ cup shredded or grated
 Parmesan cheese
1 teaspoon salt
½ teaspoon pepper
½ cup crumbled round buttery
 crackers (such as Ritz)
 or saltines
2 tablespoons butter, cut into
 small pieces

Preheat oven to 350°.

Heat oil in a small skillet over medium-high heat. Add squash
and onion; cook, stirring occasionally, for 3 to 5 minutes or
until tender.

Combine egg, sour cream, cheeses, salt, and pepper in a
large bowl, stirring until well blended. Add squash mixture,
tossing to coat. Spoon into a lightly greased 9x9-inch or
2-quart baking dish. Sprinkle with cracker crumbs and dot
with butter.

Bake 30 to 45 minutes or until golden brown.

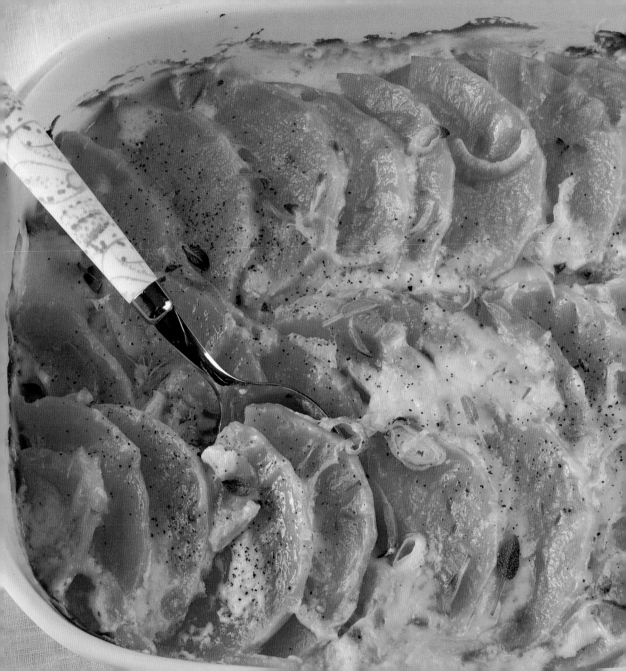

Winter Gruyère Gratin

· ·

This recipe is a riff on the traditional potato casserole. It's got a creamy rich texture that pairs
well with the dense winter squash. It's important to thinly slice the squash; otherwise,
it will take much longer to bake until tender.

· ·

makes 8 to 10 servings

INGREDIENTS
Butter
1 large butternut or
 kabocha squash
2 shallots, chopped
2 cups (8 ounces) shredded
 Gruyère cheese, divided
2 cups heavy whipping cream
1 teaspoon Dijon mustard
2 teaspoons chopped fresh sage
1 teaspoon salt
¾ teaspoon freshly ground
 black pepper
Pinch of crushed red
 pepper flakes

Preheat oven to 375°. Butter a 13x9-inch baking dish.

Peel squash and cut in half; remove seeds and discard. Cut
squash halves into ⅛-inch slices.

Arrange half of squash pieces on bottom of baking dish.
Sprinkle with shallots and 1 cup cheese. Top with remaining
squash slices and remaining 1 cup cheese.

Whisk together cream, mustard, sage, salt, pepper, and red
pepper flakes in a small bowl. Pour over squash slices.

Cover with aluminum foil and bake 1 hour or until squash is
tender and almost done. Uncover and bake 10 to 15 minutes
or until golden brown and bubbly.

Maple Butternut Squash Casserole with Pecan Streusel

Even with spices, a squash casserole can taste a bit boring. This side dish is jazzed up with a crunchy-nutty topping that makes it taste almost like dessert.

makes 6 to 8 servings

INGREDIENTS
2 (12-ounce) packages cooked butternut or other winter squash (about 2 cups puree)
¼ cup maple syrup or packed light brown sugar
1 teaspoon salt
¼ teaspoon ground cinnamon
¼ teaspoon ground cloves
¼ cup half-and-half
2 tablespoons butter, melted
1 large egg
½ teaspoon vanilla extract

TOPPING
1 cup rolled oats
⅓ cup packed light brown sugar
4 tablespoons butter, melted
¾ cup chopped pecans

Preheat oven to 375°. Coat an 11x7-inch or 2-quart baking dish with cooking spray.

Combine squash, syrup, salt, cinnamon, cloves, half-and-half, 2 tablespoons melted butter, egg, and vanilla in a large bowl. Spoon squash mixture into prepared baking dish.

To make topping, combine oats, brown sugar, 4 tablespoons melted butter, and pecans in a small bowl. Spread over squash mixture.

Bake 30 minutes or until golden brown and bubbly.

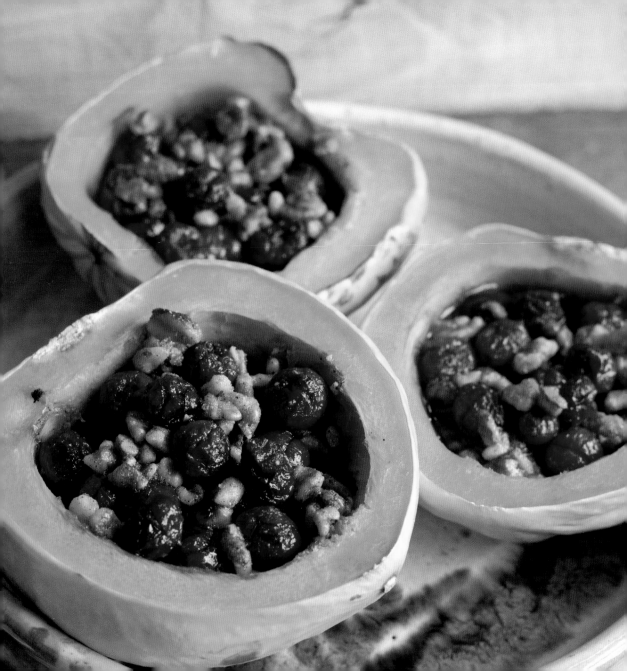

Acorn Squash with Walnuts and Cranberries

The flavors of cinnamon and cranberries blend well with winter-type squash for an easy-to-assemble side dish. If you use butternut, you may not be able to get all the filling inside, as the seed cavity is smaller. Just mound it up as best you can and cook in a casserole dish greased with butter to avoid sticking. You can scoop out servings with a spoon or cut into wedges. If cutting, spoon any spilled filling over the pieces like a sauce.

makes 4 to 8 servings

INGREDIENTS

2 acorn, carnival, or
 delicata squash
1½ cups fresh or frozen and
 thawed cranberries
⅔ cup chopped walnuts
⅓ cup packed light brown sugar
½ teaspoon ground cinnamon
⅓ cup melted butter
¼ teaspoon salt

Preheat oven to 375°.

Cut squash in half and remove seeds. Place on a rimmed baking sheet or casserole dish.

Combine cranberries, walnuts, brown sugar, cinnamon, butter, and salt in a bowl. Spoon evenly into squash halves. Cover with aluminum foil and bake 45 minutes or until squash is tender.

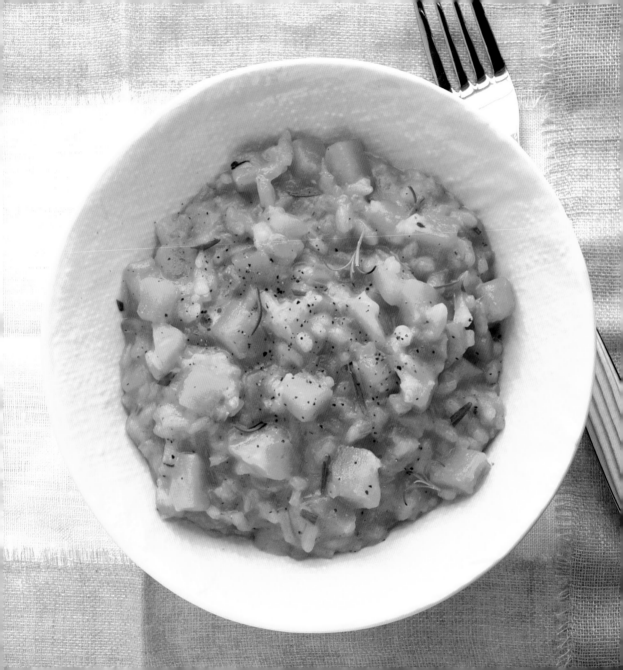

Butternut-Rosemary Risotto

Risotto is a creamy rice dish made specifically with a medium-grain Italian rice called Arborio. Arborio contains a good bit of starch that, when cooked slowly with small amounts of broth, creates a silky, saucy texture. Make sure the squash pieces are cut to the same size for even cooking.

makes 4 to 6 servings

INGREDIENTS

4 tablespoons butter
1 small onion, finely chopped
2 garlic cloves, minced
1½ cups Arborio rice
2 cups peeled and cubed butternut or other hard winter squash
½ cup white wine
4 cups chicken or vegetable broth, warm
½ cup freshly grated Parmesan cheese
2 teaspoons chopped fresh rosemary
½ teaspoon salt
¼ teaspoon coarsely ground black pepper

Melt butter in a large saucepan over medium heat. Add onion and garlic; cook, stirring constantly, for 5 minutes or until tender.

Add Arborio rice and squash; cook 1 minute, stirring constantly. Stir in wine. Cook, stirring constantly, for about 1 to 2 minutes or until wine evaporates.

Add 1 cup broth to risotto mixture and cook, stirring constantly or very frequently, until liquid is absorbed. Repeat with remaining broth, 1 cup at a time, until liquid is absorbed after each addition.

Remove from heat and stir in cheese, rosemary, salt, and pepper.

Simple Ratatouille

This classic dish tastes even better as leftovers—the flavors marry overnight and reheat easily. Eat this as a side dish, or spoon it over pasta for an entrée. You can substitute two zucchini or yellow squash for the eggplant, if you wish.

makes 8 servings

INGREDIENTS

2 tablespoons olive oil
1 onion, chopped
3 garlic cloves, minced
1 teaspoon dried
 Italian seasoning
Pinch of crushed red chile flakes
1 eggplant, peeled and diced
2 zucchini, diced
2 yellow squash, diced
4 medium tomatoes, seeded
 and diced
1 red bell pepper, chopped
¼ cup white wine or
 vegetable broth
1 bay leaf
½ teaspoon salt
¼ teaspoon coarsely ground
 black pepper
Shredded Parmesan cheese

Heat oil in a Dutch oven or deep heavy skillet over medium-high heat. Add onion, garlic, seasoning, and chile flakes. Cook, stirring frequently, for 5 minutes or until tender.

Add eggplant; cook 5 minutes. Stir in squashes, tomatoes, bell pepper, wine, bay leaf, salt, and pepper. Bring to a boil. Reduce heat and simmer, covered, for 30 minutes or until vegetables are tender.

Add more salt and pepper, to taste. Remove bay leaf and sprinkle with Parmesan cheese before serving.

soups and stews

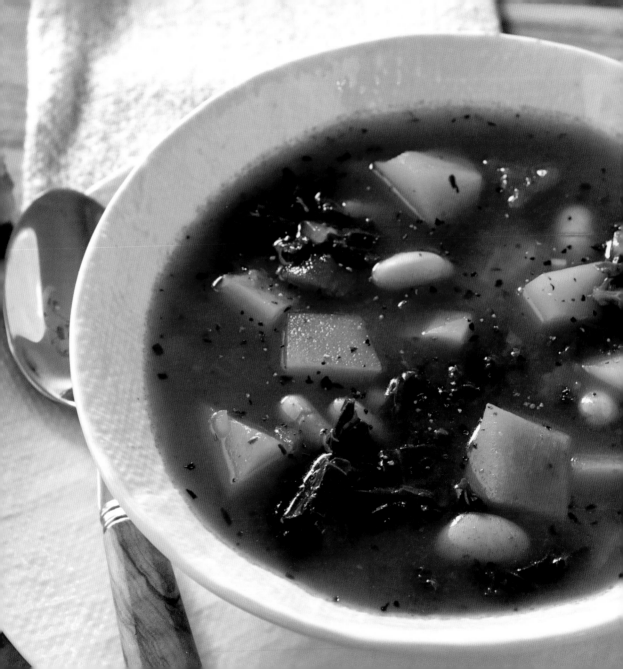

Winter Squash, Kale, and Cannellini Soup

This hearty soup is filled with nutritious ingredients that are deliciously satisfying. Substitute spinach for kale, if you prefer, and any white bean will work.

makes 6 servings

INGREDIENTS

2 tablespoons olive oil
1 onion, chopped
1 celery stalk, chopped
6 garlic cloves, minced
1 tablespoon Italian seasoning
6 cups chicken broth
2 large carrots, chopped
1 (28-ounce) can diced
 tomatoes, undrained
⅓ cup tomato paste
3½ to 4 cups diced butternut or
 other winter squash (about
 1¼–1½ pounds)
6 cups coarsely chopped
 fresh kale
1 (15.5-ounce) can cannellini
 beans, rinsed and drained
Salt and pepper, to taste

Heat oil in a Dutch oven or soup pot over medium-high heat. Add onion, celery, garlic, and seasoning. Cook, stirring often, 5 minutes or until vegetables are slightly softened.

Add broth, carrots, tomatoes, tomato paste, and squash. Bring to a boil, reduce heat, and simmer, covered, 15 to 20 minutes or until vegetables are tender. Stir in kale and beans. Cook 5 minutes, stirring occasionally, until kale wilts and soup is heated through. Season to taste with salt and pepper.

Summer Squash-and-Corn Chowder

Crispy bacon adds a rich flavor to this light soup. If you prefer a vegetarian version, skip the bacon and add smoked paprika to taste.

makes 8 servings

INGREDIENTS
4 slices bacon, chopped
4 tablespoons butter
1 red bell pepper, chopped
½ onion, chopped
2 celery stalks, chopped
Pinch of red chile flakes
¼ cup all-purpose flour
4 cups chicken or
 vegetable broth
1 cup half-and-half
¾ teaspoon salt
3 medium-size zucchini or
 yellow squash, diced
1 cup fresh or frozen corn
2 teaspoons chopped
 fresh thyme
Salt and pepper, to taste

GARNISH
 thyme sprigs

Cook bacon in a Dutch oven or large saucepan over medium heat until crispy. Remove and drain on paper towels.

Melt butter in same pan over medium heat. Add bell pepper, onion, celery, and chile flakes. Cook 5 to 7 minutes or until tender. Add flour; cook, stirring constantly, 1 minute.

Stir in broth, half-and-half, and salt. Bring to a simmer and stir in squash, corn, and thyme. Simmer 20 minutes. Season to taste with salt and pepper. Sprinkle with cooked and crumbled bacon. Garnish, if desired.

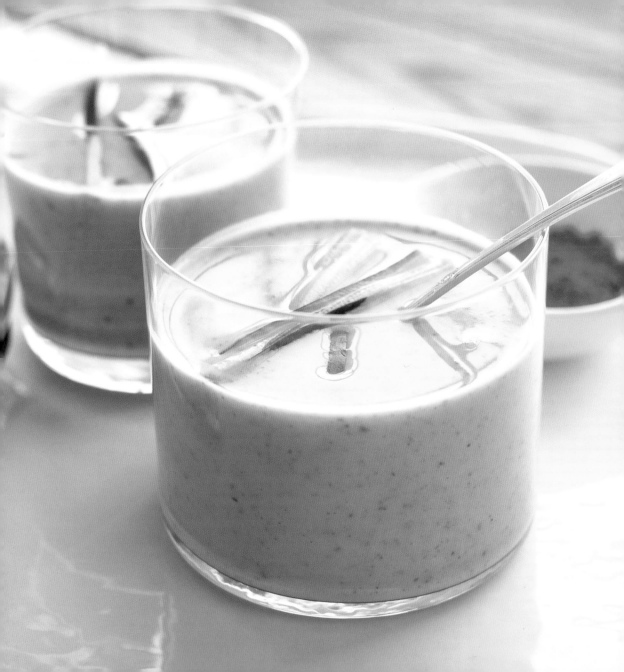

Chilled Curry-Zucchini Soup

About half the people I know turn their noses up at chilled soups, but I'll always argue how refreshing a cold soup can be on a hot summer day. This version turned my husband into a fan (at least of this soup), and I delighted in his first taste as he, with raised eyebrows, admitted, "Oh, this is good!" It's a great option for parties —served in tall shot classes or small cups so you don't need spoons—because it needs to be made ahead.

makes 6 cups

INGREDIENTS
4 medium-size zucchini, divided
1 medium-size sweet
 onion, chopped
2 cups vegetable or
 chicken broth
2 teaspoons curry powder
1 teaspoon salt
⅛ teaspoon ground white or
 black pepper
1 cup half-and-half

Julienne or cut enough zucchini into skinny matchsticks to measure about ⅓ cup. Set aside to use as a garnish.

Cut remaining zucchini into ¼-inch-thick slices. Combine sliced zucchini, onion, broth, curry powder, salt, and pepper in a saucepan over medium-high heat. Bring to a boil; reduce heat and simmer, covered, for 30 minutes.

Transfer to a blender or use an immersion blender to puree until smooth. Stir in half-and-half. Cover and refrigerate until chilled. Stir in additional curry, salt, and pepper, if desired (foods taste less salty when cold). Garnish each serving with reserved zucchini strips.

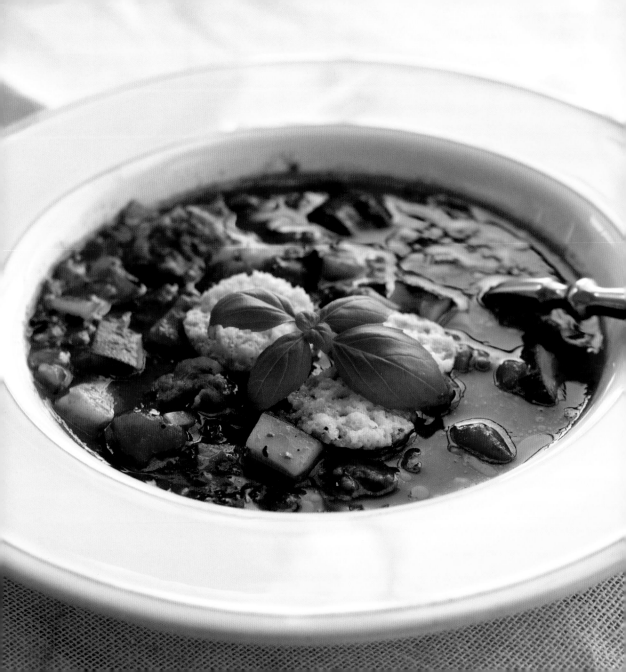

Italian Sausage– Summer Squash Soup

I like the mix of half sweet and half spicy sausage, but use all of one kind if you prefer. It may be easier to find the raw sausage in links that you can cut open and cook. If the sausage is extremely lean, you may need to add 1 tablespoon more olive oil to help it cook with the vegetables. Vegetarians can use meat-substitute crumbles, but the flavor may be too bland, so add extra Italian seasoning.

makes 12 cups

INGREDIENTS

2 tablespoons olive oil
½ pound sweet Italian bulk sausage
½ pound spicy Italian bulk sausage
1 large onion, chopped
4 celery stalks, chopped
1 green bell pepper, chopped
3 garlic cloves, minced
1 (28-ounce) can Italian-seasoned or fire-roasted diced tomatoes, undrained
1 (8-ounce) can tomato sauce
2 teaspoons dried Italian seasoning
2 teaspoons salt
1 tablespoon sugar
4 cups coarsely chopped zucchini and/or yellow squash

GARNISHES

Parmesan crackers, fresh basil sprigs

Heat olive oil in a large soup pot over medium heat. Add sausage and cook, stirring occasionally, until browned. Drain, if desired, and return to pot.

Add onion, celery, bell pepper, and garlic to sausage and cook 10 minutes, stirring occasionally, until tender. Stir in tomatoes, tomato sauce, Italian seasoning, salt, and sugar. Cover and simmer 45 minutes, stirring occasionally. Add squash and cook 10 minutes or until tender. Garnish, if desired.

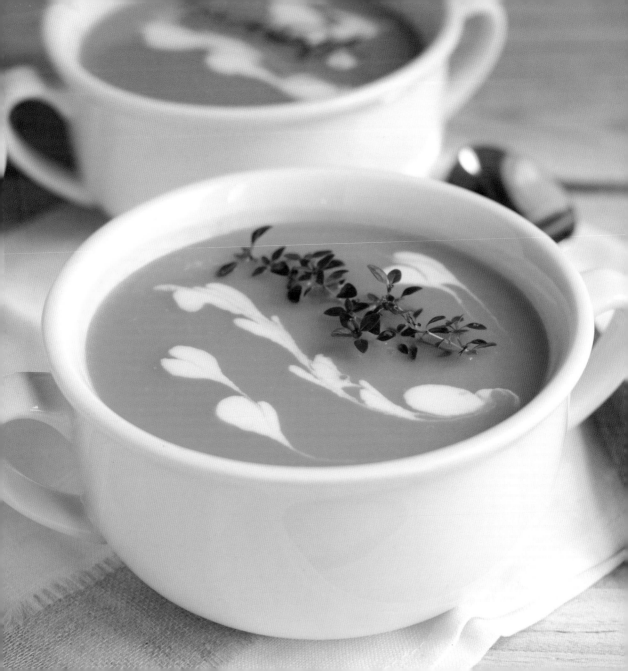

Butternut-Thyme Soup

This smooth and rich soup tastes like it's full of heavy cream, but it's much lighter. You can skip the fresh thyme, though it adds more complexity. Leftovers are no problem, as it keeps well in the fridge for 2 or 3 days, or you can freeze this soup up to 3 months. The solids will separate, but that's normal; just whisk together as you reheat.

makes 6 servings

INGREDIENTS
2 tablespoons butter
1 tablespoon olive oil
1 large sweet onion, chopped
1 tablespoon fresh lemon thyme
 or thyme leaves
4 cups cubed butternut squash
4 cups vegetable broth
¾ teaspoon salt
¼ cup crème fraiche,
 mascarpone, or sour cream

GARNISH
 fresh thyme sprigs

Heat butter and oil in a large soup pot over medium heat. Add onion and thyme; cook, stirring frequently, 10 minutes.

Stir in squash, broth, and salt. Bring mixture to a boil, reduce heat, and simmer 20 to 25 minutes or until squash is very tender.

Puree with an immersion blender until smooth. Top servings with a dollop of crème fraiche; garnish, if desired.

Note: You can also make this in an Instant Pot Cooker. Heat butter and oil using the sauté function. Add onion and thyme and sauté for 5 minutes. Stir in broth, squash, and salt. Seal with lid and cook, unvented, on high pressure for 10 minutes. Let stand 10 minutes to allow pressure to decrease. Puree with an immersion blender.

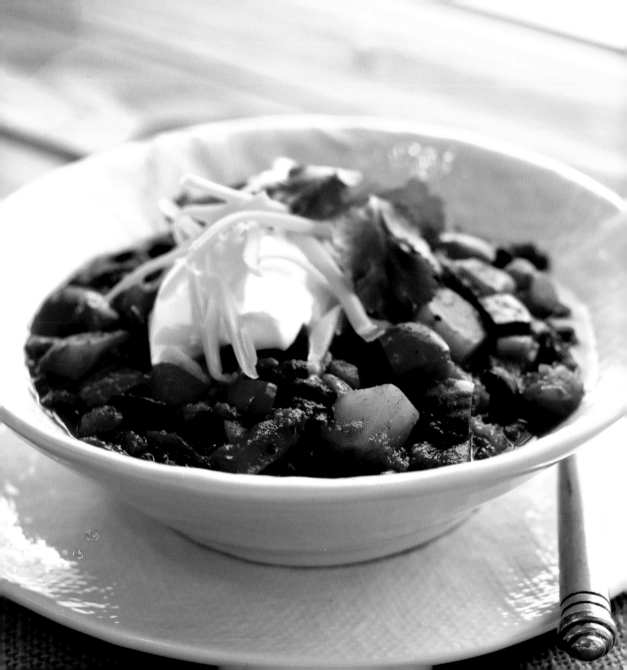

Black Bean-and-Winter Squash Chili

This vegetarian stew is hearty and filling. If you are cooking for meat lovers, brown a pound of lean ground beef, ground turkey, or cubed beef with the onions and proceed with the recipe. For ease, try frozen cubed butternut squash—you don't even have to thaw it!

makes 6 to 8 servings

INGREDIENTS

3 tablespoons olive oil
1 large onion
2 garlic cloves, minced
2 poblano peppers, chopped
1 red bell pepper, chopped
2 cups vegetable broth
2 (15-ounce) cans black beans, rinsed and drained
1 (28-ounce) can diced fire-roasted or chili seasoned tomatoes, undrained
1 (8-ounce) can tomato sauce
2 tablespoons chili powder
1 tablespoon ground cumin
2 teaspoons smoked paprika
½ teaspoon salt
¼ teaspoon pepper
3½ to 4 cups cubed or chopped butternut squash or other winter squash

TOPPINGS

sour cream, shredded Cheddar cheese, fresh cilantro

Heat oil in a large pot over medium heat. Add onion and cook, stirring frequently, 5 minutes or until tender. Add garlic; cook 2 minutes. Add poblano and red bell peppers. Cook 5 minutes, stirring constantly.

Stir in broth, beans, tomatoes, tomato sauce, chili powder, cumin, paprika, salt, and pepper. Stir in squash. Bring to a boil, reduce heat, and cook 25 minutes or until squash is tender. Serve with desired toppings.

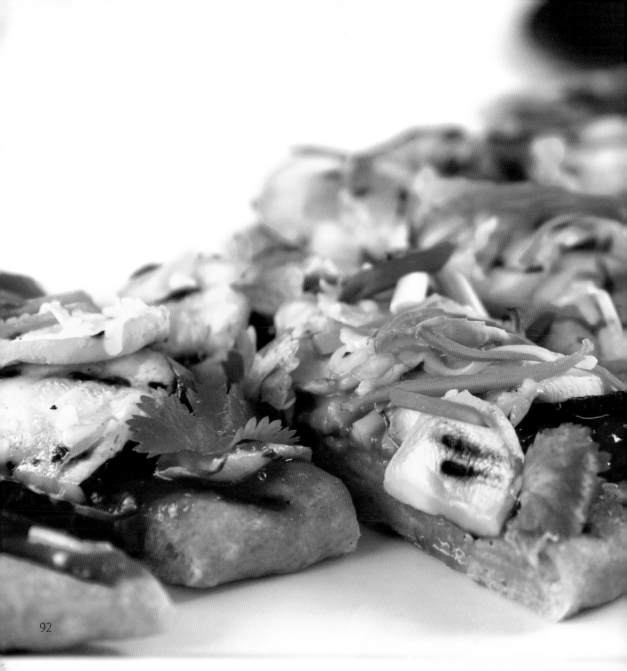

main dishes and pasta

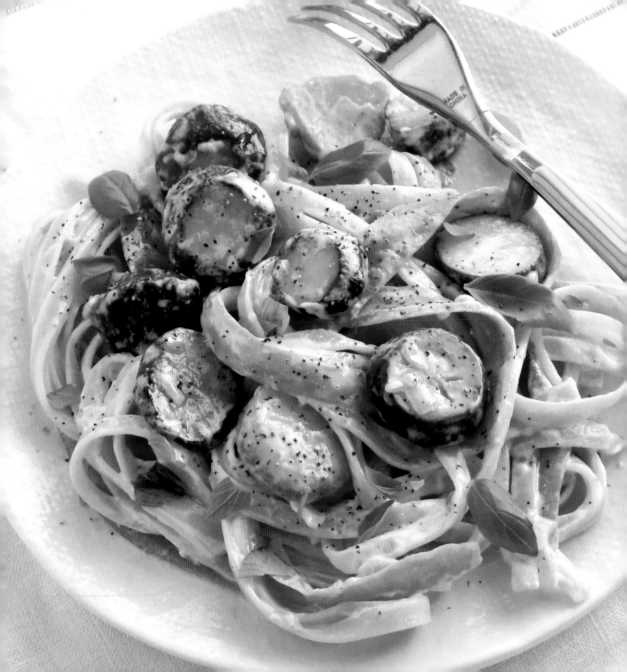

Pattypan Primavera

Pattypan are adorable, UFO-shaped squash. If large, their squatty shape means the inside may not get completely tender unless you cut it in half or quarters. Baby pattypan can be used whole. Pattypan are not always available, so substitute thick-sliced zucchini or yellow squash.

makes 4 servings

INGREDIENTS

1 pound baby pattypan squash
2 carrots
2 tablespoons butter
1 tablespoon olive oil
½ teaspoon salt
¼ teaspoon coarsely ground
 black pepper
1 sweet onion, chopped
2 garlic cloves, minced
8 ounces linguine or other pasta
1 (8-ounce) container
 crème fraiche
2 tablespoons chopped
 fresh basil
1 tablespoon fresh oregano leaves

Cut stems from squash. Cut in half or quarters, making sure pieces are about the same size. Peel carrots, and then continue to use the vegetable peeler to create ribbons.

Melt butter with oil in a large skillet over medium-high heat. Add squash, salt, and pepper; cook, stirring occasionally, 5 minutes. Add onion and garlic; cook, stirring occasionally, 3 to 5 minutes or until vegetables are tender. Add carrots; cook 1 to 2 minutes or until tender.

Cook linguine in boiling salted water until tender. Drain in a colander, and then transfer to a large bowl. Add crème fraiche, basil, and oregano, tossing until coated. Add vegetable mixture, tossing until well blended.

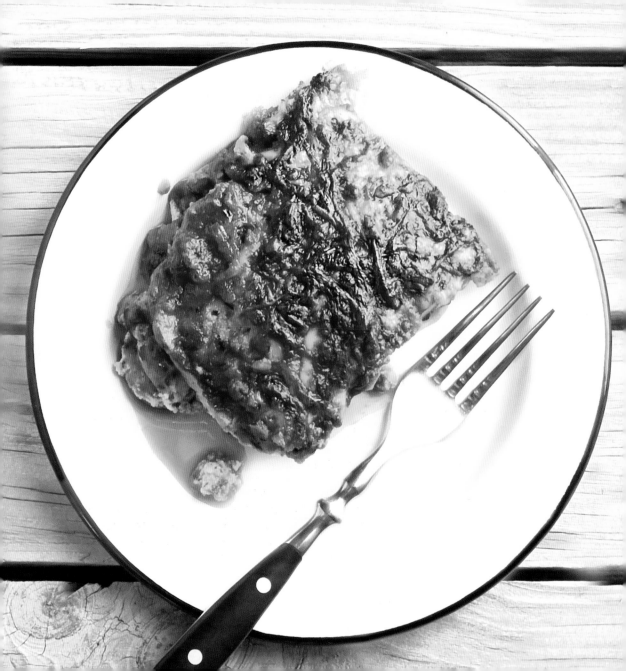

Italian Zucchini Casserole

If you enjoy lasagna but are avoiding wheat, this recipe will satisfy your craving. Using a mandoline makes it quick and easy to slice many squash into even pieces. You can slice into rounds or into long planks. Because squash has a lot of moisture compared to pasta, it'll water out less if precooked a bit.

makes 6 servings

INGREDIENTS

4 small (about 1½ pounds) zucchini
2 large eggs
2 cups ricotta cheese
1 teaspoon dried Italian seasoning
¾ teaspoon salt, divided
½ teaspoon pepper, divided
1 tablespoon olive oil
1 pound lean ground beef
3 garlic cloves, minced
1 (26-ounce) jar pasta sauce, any flavor
2 cups (4 ounces) shredded mozzarella cheese, divided
½ cup shredded Parmesan cheese

Preheat oven to 350°.

Cut zucchini ¼-inch-thick slices. Place in layers between paper towels on a plate. Microwave 3 to 5 minutes or until crisp-tender. Set aside.

Beat eggs in a large bowl. Stir in ricotta cheese, Italian seasoning, ½ teaspoon salt, and ¼ teaspoon pepper.

Heat oil in a large skillet over medium-high heat. Add beef and garlic. Cook, stirring frequently, until meat is browned and no longer pink. Drain excess liquid. Stir in pasta sauce, remaining ¼ teaspoon salt, and remaining ¼ teaspoon pepper. Cook until warm and bubbly.

Layer half of zucchini in a lightly greased 13x9-inch baking dish. Spread half of ricotta cheese mixture over zucchini and top evenly with half of beef mixture. Sprinkle with 1 cup mozzarella cheese. Repeat with remaining zucchini, ricotta mixture, beef, and 1 cup mozzarella cheese.

Bake 35 minutes. Sprinkle with Parmesan. Bake 5 to 10 minutes or until golden and bubbly.

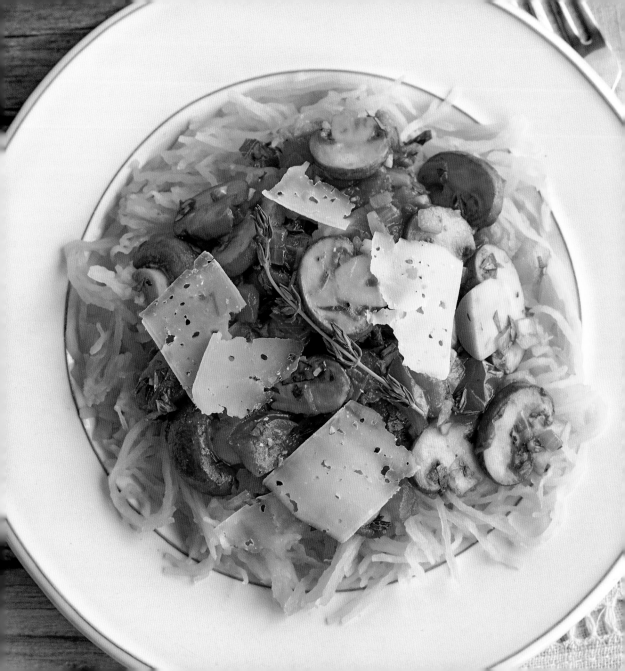

Simple Spaghetti Squash with Bacon, Butter, and Parmesan

Bacon makes everything better, and this simple spaghetti squash side dish is no exception. If you prefer a vegetarian option, skip the bacon and sprinkle with a bit of smoked paprika for a rich aroma.

makes 4 side-dish or 2 entrée servings

INGREDIENTS

1 large spaghetti squash
6 slices bacon
6 tablespoons butter, cut into small pieces
¾ teaspoon salt
¼ teaspoon freshly ground black pepper
½ to ¾ cup grated or shredded Parmesan cheese
2 tablespoons chopped fresh basil or other fresh herb

Preheat oven to 400°. Line a baking dish with aluminum foil.

Split squash in half; scoop out and discard seeds. Place squash, cut side down, on prepared baking dish; bake 35 to 40 minutes or until squash is tender when pierced with a knife. Rest until cool enough to handle.

Meanwhile, cook bacon in a skillet over medium heat until crispy. Remove and drain on paper towels; crumble and set aside.

Scrape flesh of squash into a bowl with a fork to create long, spaghetti-like strands. Add butter, salt, and pepper, tossing until butter melts and coats squash. Stir in Parmesan cheese, basil, and reserved bacon.

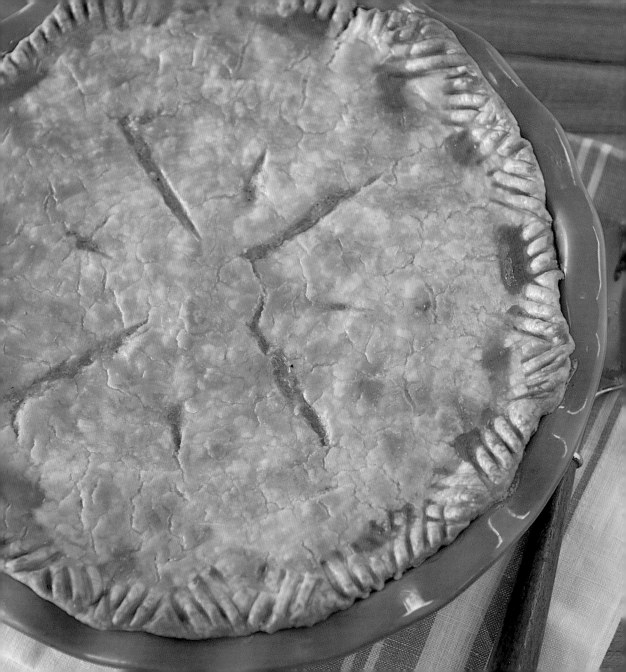

Turkey-and-Winter Squash Pot Pie

Put this recipe on your to-do list after Thanksgiving because it's great for leftover turkey (and the rest of that package of celery!). I tend to use shortcuts like refrigerated piecrusts after a big food-filled holiday, but you can substitute your favorite homemade double-crust pastry.

makes 6 servings

INGREDIENTS

4 tablespoons butter
3 stalks celery, chopped
1 medium onion, chopped
2½ cups cubed butternut squash or other winter squash
¼ cup all-purpose flour
2 teaspoons poultry seasoning
½ teaspoon salt
1 cup chicken or turkey broth
1 cup half-and-half
3 cups chopped or shredded cooked turkey
1 (15-ounce) package refrigerated piecrusts
1 egg, lightly beaten

Preheat oven to 375°.

Melt butter in a large saucepan over medium heat. Add celery and onion. Cook, stirring frequently, 5 minutes. Add squash. Cover and cook, stirring occasionally, for 10 minutes until vegetables are almost tender.

Stir in flour, poultry seasoning, and salt. Cook 1 minute.

Add broth and half-and-half, stirring until well blended. Bring to a simmer; simmer 5 minutes or until thickened and bubbly. Stir in turkey.

Place one piecrust in bottom of a 9-inch pie plate. Add filling, and cover with remaining crust. Fold over edges and crimp to seal. Make several slits in top. Brush with egg.

Bake 30 to 40 minutes or until golden brown and bubbly.

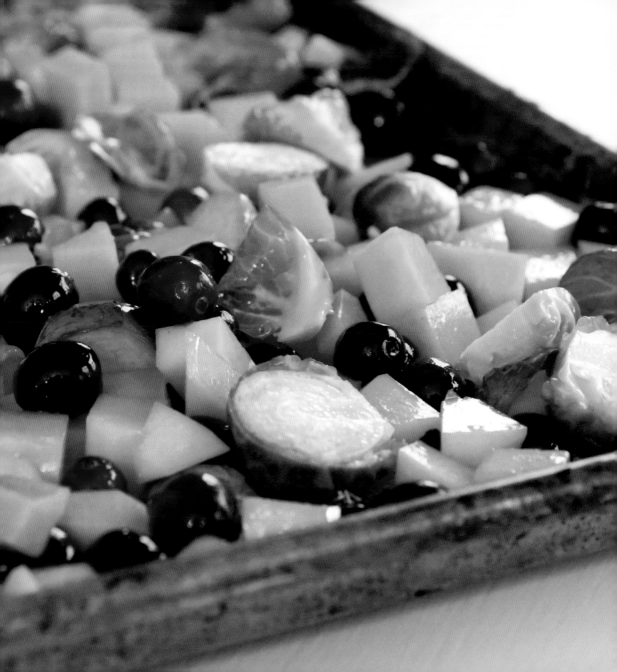

Roasted Winter Squash, Sausage, and Brussels Sprouts

For years, I roasted squash and Brussels sprouts as a side dish. Feeling a bit lazy one night about finding a protein to go with them, I tossed in some sliced smoked kielbasa sausage and ended up with an easy sheet-pan supper. Serve it over grits, polenta, or couscous for a heartier meal.

makes 6 servings

INGREDIENTS

3 cups cubed butternut or other winter squash
1 pound fresh Brussels sprouts, halved or quartered
12 to 16 ounces smoked sausage, sliced
⅓ cup fresh or dried cranberries
3 tablespoons olive oil
2 tablespoons maple syrup
1 teaspoon salt
¼ teaspoon coarsely ground black pepper

Preheat oven to 425°. Line a rimmed baking sheet with nonstick aluminum foil or a silicone baking mat.

Combine squash, sprouts, sausage, and cranberries in a large bowl. Drizzle with olive oil, maple syrup, salt, and pepper, tossing to coat.

Spread in a single layer on baking sheet. Bake 30 minutes or until golden brown and tender.

Carefully remove pan and drizzle with maple syrup. Return to oven and bake 10 more minutes.

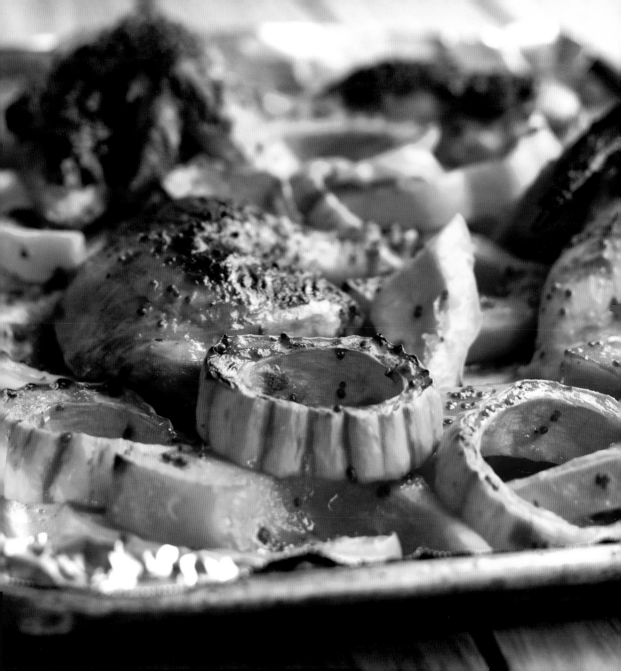

Honey-Mustard Chicken-and-Squash Sheet-Pan Supper

Aside from being a delicious one-dish meal, the point of this recipe is to be quick and simple to prepare. You can certainly use butternut for the squash, but for ease, try a thin-skinned squash that is edible without peeling, such as delicata, carnival, or acorn. Bone-in chicken will take longer to cook than the squash. To avoid overcooked squash, give the chicken a head start in the oven. Or you can use boneless chicken breasts and bake the whole recipe together. Check at 20 to 25 minutes and remove just the chicken if the squash pieces are not yet tender.

makes 4 servings

INGREDIENTS

- ¼ cup plus 1 tablespoon olive oil, divided
- ¼ cup honey
- 2 tablespoons whole-grain mustard
- 2 tablespoons Dijon mustard
- 2 teaspoons fresh lemon juice
- ½ teaspoon paprika or smoked paprika
- Salt and pepper, to taste
- 4 skin-on, bone-in chicken leg quarters or thighs
- 2 pounds thin-skinned or peeled winter squash, cut into large chunks (about 8 cups)
- 1 large sweet onion, cut into pieces
- 8 small garlic cloves, peeled

Preheat oven to 425°. Line a rimmed baking sheet with greased aluminum foil or parchment paper.

Combine ¼ cup oil, honey, mustards, lemon juice, paprika, salt, and pepper in a bowl. Set aside ¼ cup.

Heat remaining 1 tablespoon oil in a heavy skillet over medium-high heat. Add chicken and sear 3 to 4 minutes on each side. Place chicken on sheet pan and brush with some of the honey-mustard mixture. Bake 20 minutes. Remove from oven.

Carefully spread squash, onion, and garlic evenly on sheet pan around chicken. Spread or brush all but the reserved ¼ cup honey-mustard mixture over chicken and vegetables.

Bake 35 minutes or until chicken is cooked through and vegetables are tender. Brush with remaining ¼ cup honey-mustard mixture. If desired, broil for 4 to 5 minutes to brown chicken and crisp skin. Remove from oven; let rest 5 minutes.

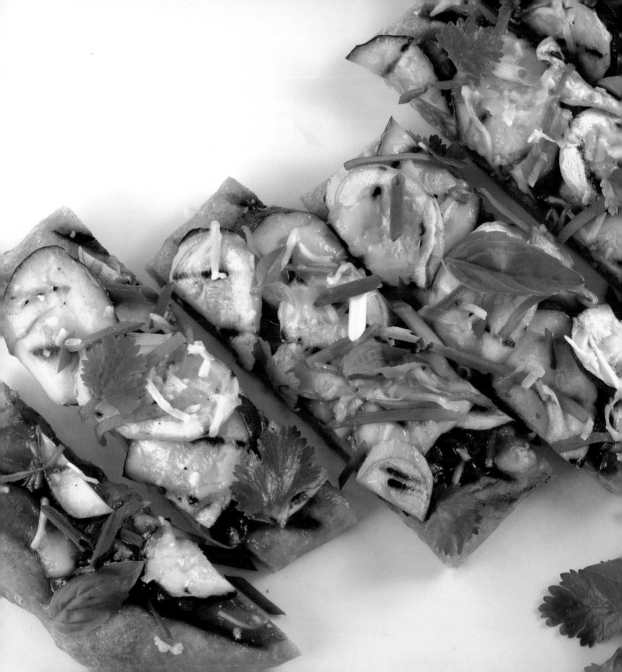

Grilled Thai Squash Pizza

Grilling the dough and veggies adds rich, amazing flavor, but you can use a grill pan on the cooktop for ease and cook the pizza in the oven. You can even skip grilling the squash altogether and use raw zucchini. Slice it very thinly, keeping in mind that you'll probably only use half the amount to avoid overcrowding the top.

makes 2 to 4 servings

INGREDIENTS

3 tablespoons creamy
 peanut butter
¼ cup firmly packed light
 brown sugar
2 tablespoons soy sauce
2 teaspoons rice vinegar
1 teaspoon grated fresh
 gingerroot
1 teaspoon Sriracha or chili-
 garlic paste, or to taste
Extra virgin olive oil
1 small zucchini, sliced
1 yellow squash, sliced
1 pound uncooked pizza dough
1 small carrot, julienned
 or shredded
½ cup (2 ounces) shredded
 Swiss cheese
½ cup (2 ounces) grated
 Parmesan cheese
1 green onion, cut into slivers
¼ cup loosely packed fresh
 cilantro and/or basil leaves

Preheat grill to medium-high heat.

Combine peanut butter, brown sugar, soy sauce, vinegar, gingerroot, and Sriracha in a glass bowl. Microwave 30 seconds. Stir until peanut mixture is smooth and sugar dissolves.

Brush grill grates with oil. Grill squash slices 2 to 3 minutes on each side or until marked and tender. Set aside.

Divide dough into 2 or 3 pieces. Roll or press flat to about ¼-inch thick. Brush with oil; grill dough 3 minutes on each side or until marked and almost done.

Layer squash, carrot, and cheeses evenly on dough. Grill 3 to 5 minutes or until pizza is hot and bubbly. Top with green onion and herbs.

Baked Variation: Preheat oven to 450°. Spread peanut mixture over large uncooked round pizza crust. Top with squash, carrot, and cheeses. Bake 10 to 12 minutes or until pizza is hot and bubbly. Top with green onion and herbs.

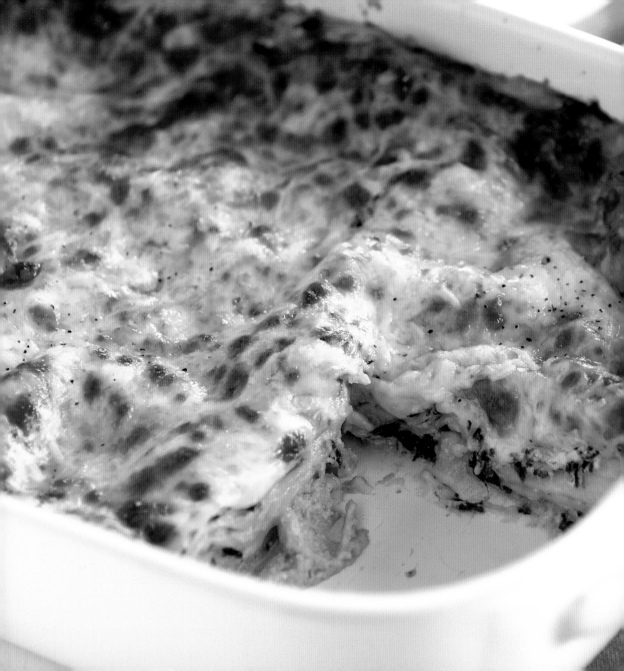

Butternut Squash-and-Spinach Lasagna

For a shortcut, use packaged frozen squash puree. Using no-boil noodles is another time-saver; these work best when the lasagna is saucy with plenty of moisture for the noodles to absorb. They appear puny in the pan when assembling, but they will plump up while cooking.

makes 8 servings

INGREDIENTS

2 (12-ounce) packages frozen butternut or winter squash puree (about 2 cups), thawed
2 cups ricotta cheese, divided
¾ cup milk
1 tablespoon chopped fresh sage
2 teaspoons salt, divided
1 (10-ounce) package frozen chopped spinach, thawed and lightly squeezed dry
2 cups (8 ounces) shredded reduced-fat mozzarella cheese, divided
½ cup (2 ounces) freshly grated Parmesan cheese, divided
¼ teaspoon freshly ground black pepper
9 no-boil lasagna noodles, divided

Preheat oven to 400°. Lightly grease a 13x9-inch baking dish.

Combine squash, 1 cup ricotta cheese, milk, sage, and 1½ teaspoons salt in a medium bowl.

Combine spinach, remaining 1 cup ricotta, 1 cup mozzarella, ¼ cup Parmesan cheese, remaining ½ teaspoon salt, and pepper in another medium bowl.

Spread one-half of the squash mixture in bottom of prepared baking dish. Arrange 3 noodles over sauce (noodles will appear small but will increase in size as they cook and absorb liquid). Top with one-half of the spinach mixture and 3 noodles. Repeat with remaining one-half squash mixture, remaining 3 noodles, and remaining one-half spinach mixture. Sprinkle with remaining 1 cup mozzarella and remaining ¼ cup Parmesan cheese.

Cover with aluminum foil and bake 30 minutes. Uncover and bake 15 more minutes or until lasagna is bubbly and cheese is golden brown. Let cool 10 minutes.

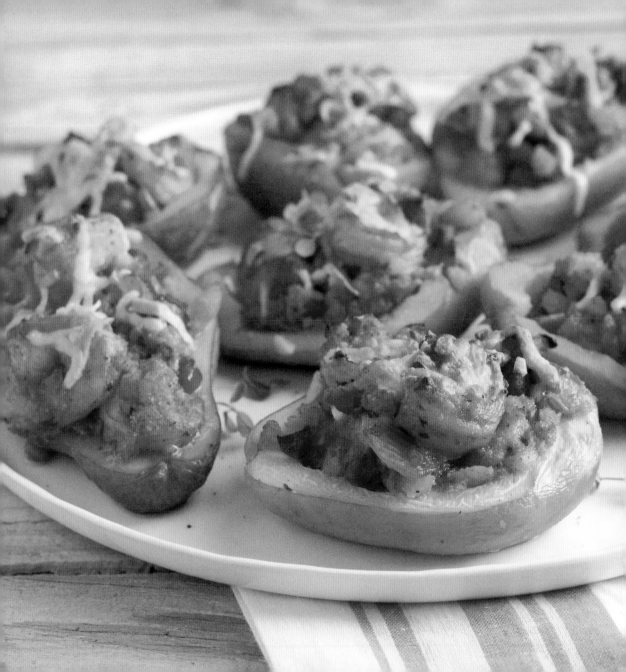

Creole-Stuffed Chayote

In Louisiana, you'll see these interesting edible gourds called mirlitons or sometimes vegetable pears. They are pale green with a lumpy pear shape. You can substitute zucchini, yellow squash, or delicata for them, but do not boil before scooping out the pulp.

makes 8 servings

INGREDIENTS

4 chayote squash or mirlitons
3 tablespoons butter
8 ounces Andouille sausage or
 smoked ham, chopped
1 red bell pepper, seeded
 and chopped
2 large celery stalks, chopped
1 small onion, chopped
1 teaspoon fresh thyme leaves
1 teaspoon Creole or
 Cajun seasoning
¾ pound peeled and chopped
 small shrimp or crawfish tails
2 garlic cloves, minced
¼ cup dried Italian panko
 or breadcrumbs
2 green onions, finely chopped
¼ tablespoon finely shredded
 Parmesan cheese

Cook squash in boiling salted water to cover for 30 to 35 minutes or until fork-tender; drain. When cool enough to handle, cut in half lengthwise and remove the large seed from each one.

Scoop out pulp from inside, leaving a ¼- to ½-inch border. Turn shells upside down on a wire rack to continue draining until ready to stuff. Chop pulp and drain on paper towels.

Preheat oven to 325°.

Melt butter in a large skillet over medium heat. Add sausage and cook, stirring frequently, until browned. Add bell pepper, celery, onion, thyme, and seasoning. Cook 8 to 10 minutes, stirring frequently, until vegetables are tender. Stir in shrimp; cook 3 minutes or until done. Stir in garlic and reserved squash pulp. Cook 2 minutes, stirring frequently. Fold in breadcrumbs.

Place squash shells in a baking dish and top evenly with shrimp mixture. Sprinkle with green onions and Parmesan cheese. Cover with aluminum foil and bake 25 minutes. If desired, remove foil and broil for 3 minutes or until tops are golden brown.

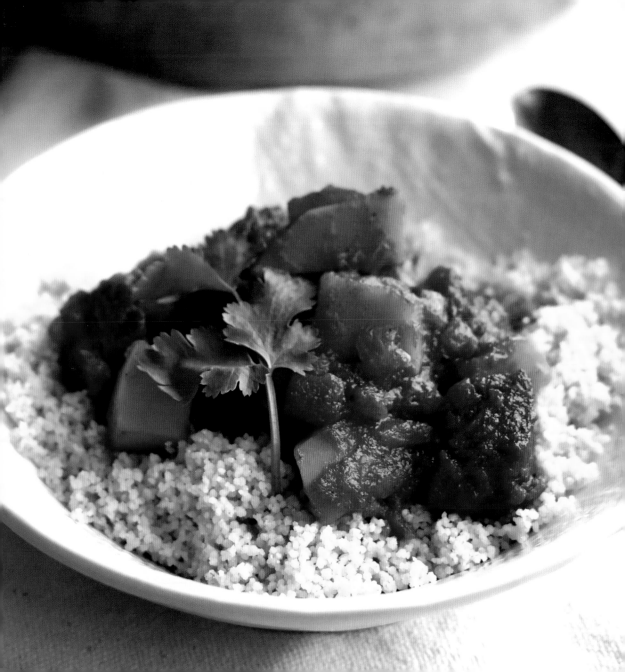

Beef Tagine with Winter Squash

Tagines, both the name of the dish and the vessel it cooks in, are basically Moroccan one-pot meals. A tagine pot is a shallow, round pan with a conical lid. The design enables condensation to rise to the top, condense, then drip down to baste the food, keeping it moist and succulent. Check the manufacturer's directions, as many clay tagines cannot be used on a cooktop. Some tagines have steel or cast iron bases, which are safe for gas or electric cooktops.

makes 4 to 6 servings

INGREDIENTS

1 tablespoon paprika
2 teaspoons salt
1½ teaspoons ground cumin
½ teaspoon ground cinnamon
½ teaspoon ground ginger
½ teaspoon crushed red
 pepper flakes
1 teaspoon smoked paprika
1 pound lean boneless beef,
 cut into cubes
2 tablespoons olive oil
1 small sweet onion, chopped
2 garlic cloves, minced
1 cup beef, chicken, or
 vegetable broth
1 (28-ounce) can crushed or
 diced tomatoes, undrained
1 small (1½-pound) peeled and
 cubed butternut or other
 winter squash
½ cup golden raisins (optional)
Hot cooked couscous
¼ cup chopped fresh cilantro

Combine paprika, salt, cumin, cinnamon, ginger, pepper flakes, and smoked paprika in a large bowl. Add beef, tossing to coat. Set aside. (Beef may be refrigerated several hours until ready to cook.)

Heat oil in a large (cooktop safe) tagine bottom, Dutch oven, or soup pot over medium-high heat. Add beef and onion; cook, stirring occasionally, until beef is browned on all sides. Add garlic; cook 1 minute.

Stir in broth and tomatoes; cook 5 minutes. Add squash and, if desired, raisins. Cover, reduce heat to low, and cook 25 minutes or until squash is tender. Serve over couscous and sprinkle with cilantro.

desserts

Nutty Squash Cookies

Many gardeners look for ways to use zucchini, and this tender cookie is a delicious answer to an overabundance of the prolific grower. This cookie is so tasty and moist, you'll be growing the squash just to make this treat, rather than the other way around. If you are making the recipe for kids, consider omitting the walnuts and substituting dried cranberries or raisins.

makes 3 dozen

INGREDIENTS

2 cups grated zucchini or other summer squash (about 3 small or 1 pound)
1 teaspoon salt, divided
½ cup butter, softened
½ cup granulated sugar
½ cup packed light brown sugar
1 large egg
1 teaspoon vanilla extract
1 cup all-purpose flour
1 teaspoon baking powder
1 teaspoon ground cinnamon
1 cup rolled oats (regular or quick-cooking)
1 cup semisweet or sweet dark chocolate morsels
1 cup chopped walnuts or pecans

Combine zucchini and ½ teaspoon salt in a colander, tossing to mix well. Drain over a bowl or sink 20 to 30 minutes, pressing occasionally to squeeze out liquid.

Preheat oven to 375°. Line baking sheets with parchment paper, greased aluminum foil, or silicone baking mats.

Beat together butter and sugars with an electric mixer until light and fluffy. Beat in egg and vanilla. Stir in zucchini.

Whisk together flour, baking powder, cinnamon, and remaining ½ teaspoon salt. Stir into zucchini mixture. Stir in oats, morsels, and nuts.

Drop by tablespoons onto baking sheets. Bake 15 minutes. Cool on baking sheet 2 to 3 minutes, and then transfer to wire racks to cool completely.

Squash Spice Cake

This yummy cake is a riff on the traditional Southern favorite dessert, Hummingbird cake, with grated squash subbing in for mashed bananas. While cakes can be time-consuming, it's faster if you just put the frosting between the layers and don't try to frost the sides. It can be covered and frozen up to 3 months. Remember, it's a dense cake, so remove it from the freezer a few hours before serving so the inside isn't solid.

makes 10 to 12 servings

INGREDIENTS

2 cups all-purpose flour
2 teaspoons baking powder
1 teaspoon baking soda
½ teaspoon salt
2½ teaspoons pumpkin pie
 spice or ground cinnamon
3 large eggs
1½ cups granulated sugar
½ cup packed light brown sugar
¾ cup vegetable oil
¾ cup buttermilk
2 teaspoons vanilla extract
2 cups grated zucchini or
 butternut squash
1 (8-ounce) can crushed
 pineapple, undrained
1 cup sweetened flaked coconut
1 cup toasted pecans, chopped
Cream Cheese Frosting
 (recipe at right)

GARNISH

chopped pecans

Preheat oven to 350°. Coat 3 (9-inch) round cake pans with cooking spray. Line bottoms with parchment paper and coat with cooking spray.

Combine flour, baking powder, baking soda, salt, and pumpkin pie spice in a large bowl.

In a separate large mixing bowl, beat eggs, sugars, oil, buttermilk, and vanilla until well blended. Add flour mixture, beating at low speed until well blended. Fold in squash, pineapple, coconut, and pecans. Pour batter evenly into prepared cake pans.

Bake 23 to 25 minutes or until a wooden toothpick inserted in centers of cakes comes out clean. Cool cakes in pans on wire racks for 10 minutes. Remove from pans and cool completely on wire racks. Peel off parchment paper. Frost cake with Cream Cheese Frosting. Garnish, if desired.

Cream Cheese Frosting: In a large bowl, beat **1 (8-ounce) package cream cheese** (softened) and **½ cup softened butter** at medium speed with an electric mixer until fluffy. Slowly beat in **3 cups powdered sugar**. Beat in **1 to 1½ teaspoons vanilla extract**. Cover and chill 1 hour. Makes 3 cups.

Zucchini Lemon Tea Cake

This recipe bounced back and forth from breads and breakfasts to desserts. It can really go either way, but it tends to seem more like a dessert with the lemon icing drizzled on top. For breakfast, skip the drizzle and crisp it up in a toaster oven with a schmear of softened cream cheese.

makes 10 to 12 servings

CAKE
1½ cups all-purpose flour
1 teaspoon baking powder
½ teaspoon baking soda
½ teaspoon salt
2 large eggs
1 cup sugar
½ cup vegetable oil
3 tablespoons fresh lemon juice
1 cup finely shredded unpeeled
 zucchini or yellow squash

ICING
½ cup powdered sugar
1 teaspoon lemon zest
1 tablespoon fresh lemon juice

Preheat oven to 325°. Line a 9x5-inch loaf pan with nonstick aluminum foil or regular foil that's been greased and floured.

To make the cake, combine flour, baking powder, baking soda, and salt in a medium-size bowl.

Whisk together eggs and sugar in a large bowl until smooth. Whisk in oil and 3 tablespoons lemon juice. Stir in zucchini. Add flour mixture to zucchini mixture, stirring just until moistened. Spoon batter into prepared pan.

Bake 50 to 55 minutes or until a toothpick inserted in center comes out clean. Cool in pan on a wire rack 10 minutes; remove from pan and cool completely.

To make the icing, stir together powdered sugar, lemon zest, and 1 tablespoon lemon juice. Drizzle over bread when completely cooled.

Pumpkin-Pecan Dessert

I found this recipe in the vintage recipe card box that belonged to my mom, Helen. It's something she used to make for her bridge parties. As a kid, I wouldn't touch it because of the nuts, but now that I've developed a love of pecans, I'm willing to make, take, and eat this myself. I suspect it's a recipe found on the back of a box of cake mix, but because the recipe card doesn't have a space for credits, I can only guess. The recipe originally included a can of evaporated milk, but I also use cream or whole milk. I also use a bit less sugar than the original and insist on butter, rather than margarine.

makes 16 servings

INGREDIENTS
1 (15-ounce) can pumpkin
¾ cup sugar
¾ cup heavy cream or
 whole milk
3 large eggs
1 teaspoon ground cinnamon
1 teaspoon salt
1 teaspoon vanilla extract
1 (15.25-ounce) box yellow
 cake mix
1½ cups chopped pecans
1 cup butter, melted
Sweetened whipped cream
 (optional)

Preheat oven to 350°. Line a 13x9-inch baking pan with nonstick aluminum foil.

Combine pumpkin, sugar, cream, eggs, cinnamon, salt, and vanilla in a large bowl. Spoon batter into prepared baking pan.

Sprinkle cake mix evenly over top of batter. Sprinkle evenly with pecans. Drizzle evenly with butter.

Bake 55 to 60 minutes or until set. Cool completely; cut into squares.

Serve with sweetened whipped cream, if desired.

Spiced Pumpkin Pie

Canned pumpkin is easy to find and makes this dessert simple to put together quickly. Substitute pureed butternut or any other winter squash for a twist. Sometimes I end up with a few tablespoons of extra filling, depending on the pie plate. Don't fret; just fill to the edge of the pastry and carefully slide it into the oven. Decorate the edges with piecrust cutouts. You can place them on the edge of the pie as it bakes, but the no-fail method is to bake them separately on a baking sheet for 12 minutes like cookies.

makes 8 servings

INGREDIENTS

1 unbaked deep-dish piecrust
 (frozen, refrigerated,
 or homemade)
½ cup granulated sugar
⅓ cup lightly packed light
 brown sugar
1½ teaspoons ground cinnamon
½ teaspoon salt
¾ teaspoon ground ginger
¼ teaspoon ground cloves
¼ teaspoon ground nutmeg
3 large eggs
1 (15-ounce) can or 2 cups
 pumpkin puree
1 cup cream, half-and-half,
 or milk
1 teaspoon vanilla extract
1 beaten egg (optional)

Preheat oven to 375°. Fit piecrust into a pie plate.

Whisk together sugars, cinnamon, salt, ginger, cloves, and nutmeg in a small bowl. (This is so the spices blend evenly and don't clump.)

Beat eggs in a large bowl. Stir in pumpkin and sugar mixture. Whisk in cream and vanilla.

Pour mixture into piecrust. Crimp edges or decorate with additional pastry crust pieces. If desired, brush edges with beaten egg.

Place pie on a baking sheet. Bake 40 to 50 minutes, shielding crust with aluminum foil, if necessary, to avoid overbrowning. It's okay if the pie is slightly jiggly in the center; it should firm as it cools. To test for doneness, insert a knife near the center to see if it comes out clean. Cool on a wire rack. Serve at room temperature or chill until serving.

Double Chocolate Squash Cake

Admittedly, this moist and tender cake is more about the chocolate than the grated squash. Still, it's a fantastic way to sneak in some healthy food or use up excess garden bounty. Leftovers are delicious when gently warmed in the microwave or toaster oven.

makes 10 servings

INGREDIENTS

1¼ cups granulated sugar
¾ cup packed light brown sugar
1 cup vegetable oil
3 large eggs
2 teaspoons vanilla extract
½ cup milk, sour cream, or yogurt
2½ cups all-purpose flour
⅔ cup cocoa powder
1½ teaspoons baking powder
1½ teaspoons baking soda
¾ teaspoon ground cinnamon (optional)
½ teaspoon salt
2 cups grated zucchini or yellow squash
2½ cups (20 ounces) dark or semisweet chocolate chips, divided
¾ cup heavy cream

Preheat oven to 325°. Grease and flour a 12-cup Bundt pan.

Combine sugars, oil, eggs, and vanilla in a large mixing bowl. Whisk in milk.

Combine flour; cocoa powder; baking powder; baking soda; cinnamon, if desired; and salt in a bowl. Stir flour mixture into sugar mixture. Fold in zucchini. Fold in 1 cup chocolate chips.

Pour batter into prepared pan. Bake 60 minutes or until a toothpick comes out clean when inserted in center of cake.

Cool cake in pan 10 minutes. Invert onto a wire rack and cool completely.

Heat cream in a small saucepan over low heat or in a glass bowl in the microwave until hot but not boiling. Add remaining 1½ cups chocolate chips and let stand 1 minute. Stir until smooth. Pour chocolate ganache over cake or serve on the side.

Pumpkin Spice Ice Cream

Aside from the leaves turning gold, amber, and red, you know it's fall when "pumpkin spice" ends up as a flavor for just about everything, from cereal to coffee. This ice cream has a cooked custard base, which means it will be rich and creamy. Serve it on its own with spiced pecans, or sandwich some between soft ginger or molasses cookies for a delightful handheld treat.

makes about 8 cups

INGREDIENTS

2 cups milk
1 vanilla bean, split lengthwise
8 egg yolks
¾ cup granulated sugar
¼ cup packed light brown sugar
1½ teaspoons ground cinnamon
½ teaspoon ground nutmeg
½ teaspoon salt
3 cups heavy whipping cream
1 cup canned pumpkin puree
Spiced or toasted pecans or
 pepitas (optional)

Place milk in a medium-size saucepan over medium heat. Scrape vanilla seeds into milk, whisking until blended, and add pod. Cook 2 minutes or until mixture is warm but not boiling. Cover and set aside for at least 30 minutes. Discard vanilla pod.

Combine egg yolks, sugars, cinnamon, nutmeg, and salt in a large bowl. Whisk until well blended. Whisk egg mixture gradually into milk mixture.

Cook over low heat, whisking constantly, until a thermometer registers 160°. Strain, if necessary, through a wire mesh strainer to remove any cooked egg pieces. Cool to room temperature.

Combine egg mixture, whipping cream, and pumpkin puree. For best results, allow mixture to chill overnight so the flavors blend. Or cover and chill until cold.

Pour mixture into the freezer container of an ice-cream maker. Freeze according to manufacturer's directions. Pack into a container; cover and freeze until firm. Serve with spiced or toasted pecans, if desired.

Index

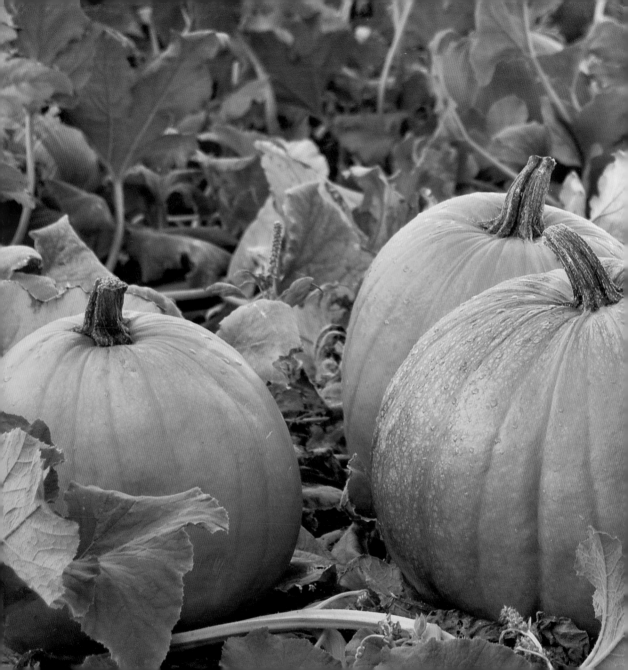

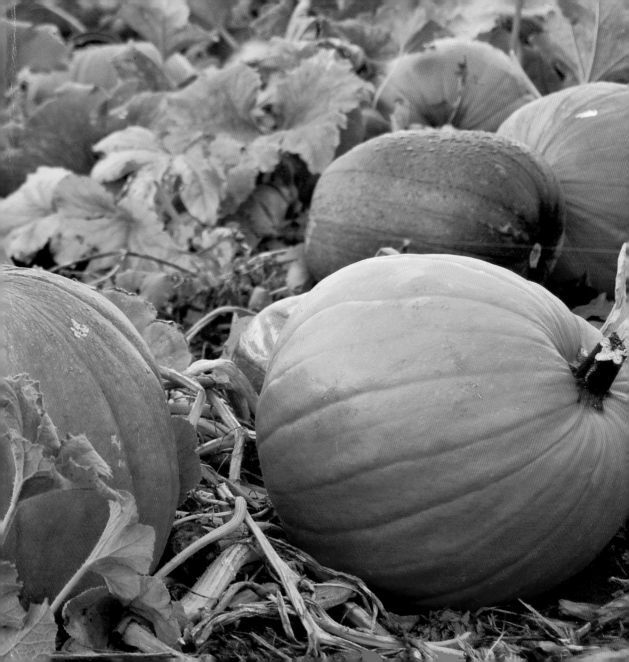

About the Author

Julia Rutland is a Washington, D.C.-area food writer and recipe developer whose work appears regularly in publications and websites such as Weight Watchers books, *Southern Living* magazine, *Coastal Living* magazine, Myfitnesspal.com, and more. She is the coauthor of *Discover Dinnertime* and a contributor to many other cookbooks and websites.

Julia lives in Purcellville, Virginia, with her husband, two daughters, a cat, a couple of dogs, too many chickens, and whatever animals decide to adopt them.

Visit Julia online at www.juliarutland.com